KELSEY M

is an international street artist who believes that art should not be separated from the human experience, but that the human experience should have a hand in creating the art itself.

Kelsey has painted large scale, interactive street murals in six countries on three continents. Each piece has provided an opportunity for thousands of people to become living works of art. Participants are invited to step in to the artwork, explore what inspires them, and post pictures on social media under the Instagram hashtag **#whatliftsyou**. Kelsey's art has been featured by the *New York Times*, *The Wall Street Journal*, *Forbes*, Mashable and MTV, as well as seen on the Instagram accounts of Taylor Swift and Vanessa Hudgens.

The *What Lifts You* coloring book is a natural outcome of Kelsey's philosophy that creating art should be an interactive, thought-provoking and uplifting experience.

 @kelseymontagueart

Author Photo: Annie Escobar

WHAT LIFTS YOU

UPLIFTING DESIGNS TO COLOR & CREATE

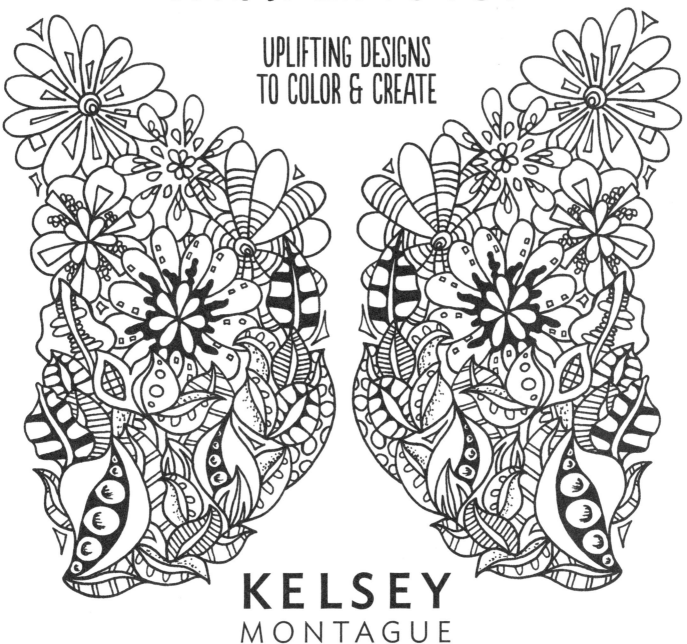

KELSEY
MONTAGUE

INTERNATIONAL STREET ARTIST

#WhatLiftsYou

WHAT LIFTS YOU: UPLIFTING DESIGNS TO COLOR & CREATE

ISBN-13: 978-0-373-09999-3

www.Harlequin.com

Printed in U.S.A.

Hey Guys,

Thank you for buying this coloring book!

I started the #WhatLiftsYou campaign in 2014 in the form of a huge pair of angel wings on a New York City street. Thousands of people stood with the piece, posted about it online and described what lifts and inspires them in their lives. That single piece of street art turned into a global campaign. People from all over the world wanted a pair of #WhatLiftsYou wings in their community. And communities from all over the world answered the call to interact with the piece and describe what lifts them.

But I wanted to involve more people in the **#WhatLiftsYou** campaign and that is where the idea for this coloring book came from.

Each page within this book invites you to color in inspirational images but to also take it one step further. In the Share Your Dreams section fill out the questions. In the What's Missing section add your own art. In the 3D art section take the pages out and use them as frames, masks or crowns! Or use the toucans as origami paper (check out my website for origami instructions). This book is all about sharing **YOUR** creativity!

And for each and everything you do please share it in the #WhatLiftsYou hashtag on social media (especially Instagram). I **LOVE** seeing photos of people from around the world interacting with art and commenting on what lifts them in their lives.

So please join the #WhatLiftsYou community and I hope you enjoy this book as much as I have enjoyed creating it!

XX,

Kelsey Montague

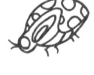
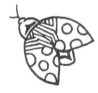
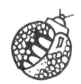
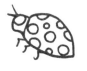

I have always found my support and inspiration by surrounding myself with strong people. Creating this coloring book is no exception. I want to give special thanks to the following extraordinary people...

My literary agent, Brianne Johnson, an NYC warrior who has also become a great friend. My editor, Ann Leslie Tuttle, who believed in this project from the first moment. My mom & mentor, Linda, for always, always believing in me. My greatest supporter and most loyal fan, my dad, Clay.

And most importantly to my sister, best friend, business partner and hero, Courtney Montague...who came up with the idea in the first place.

THIS BOOK BELONGS TO:

#WHATLIFTSYOU

COLOR AND FRAME
YOUR WORLD

#WHATLIFTSYOU

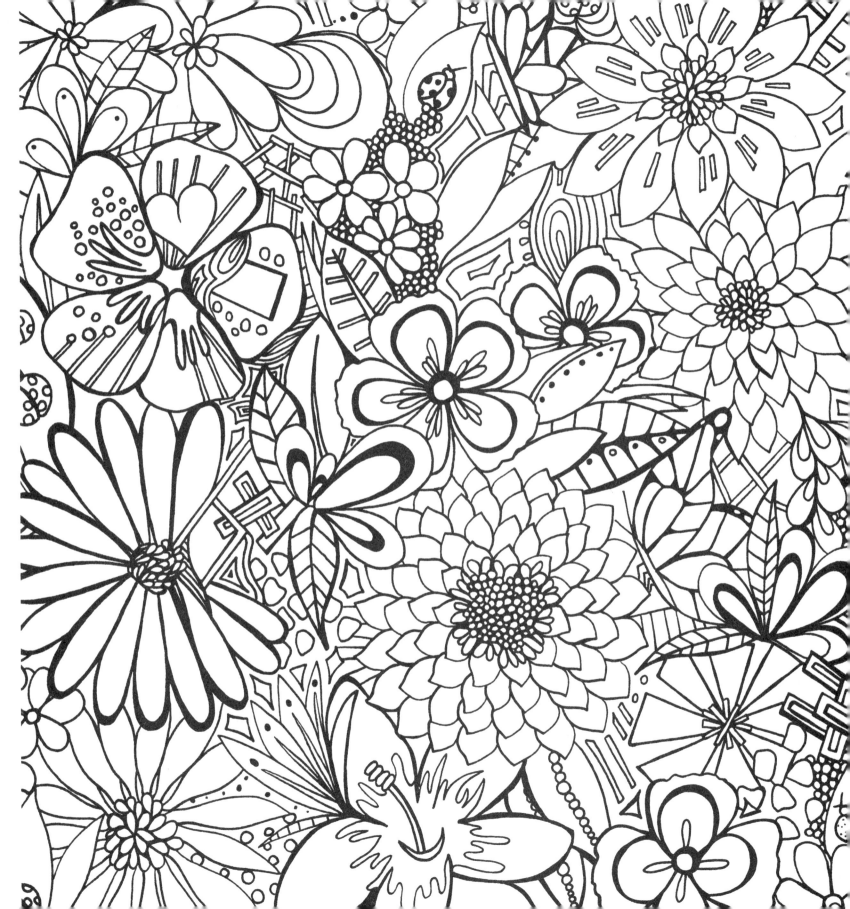

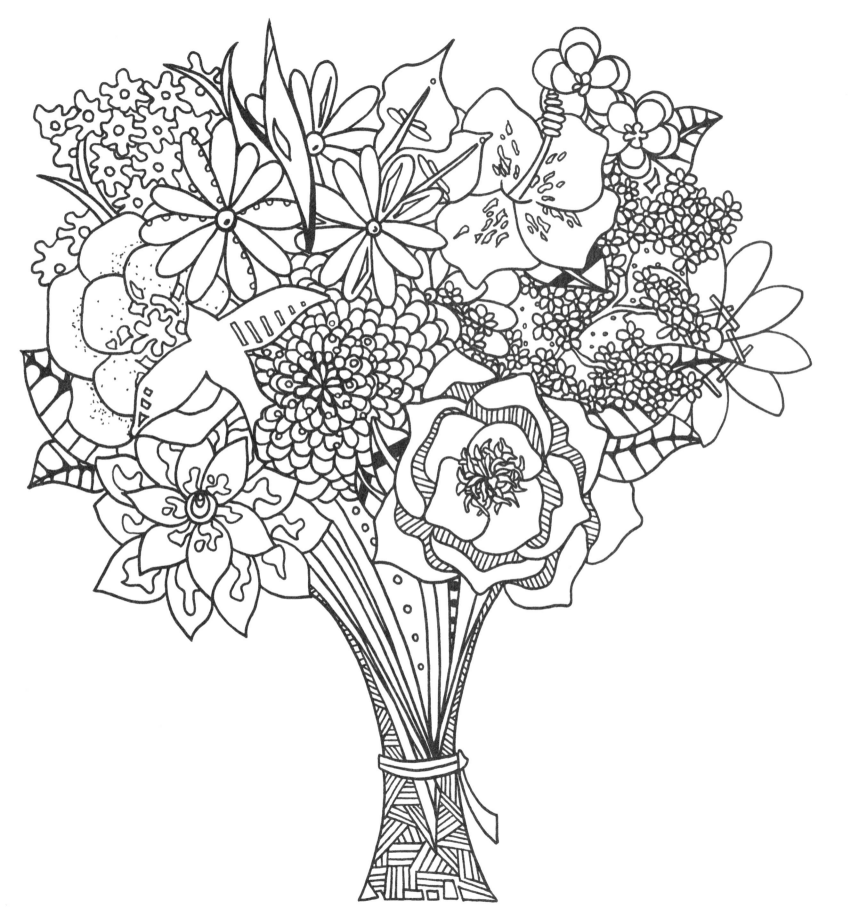

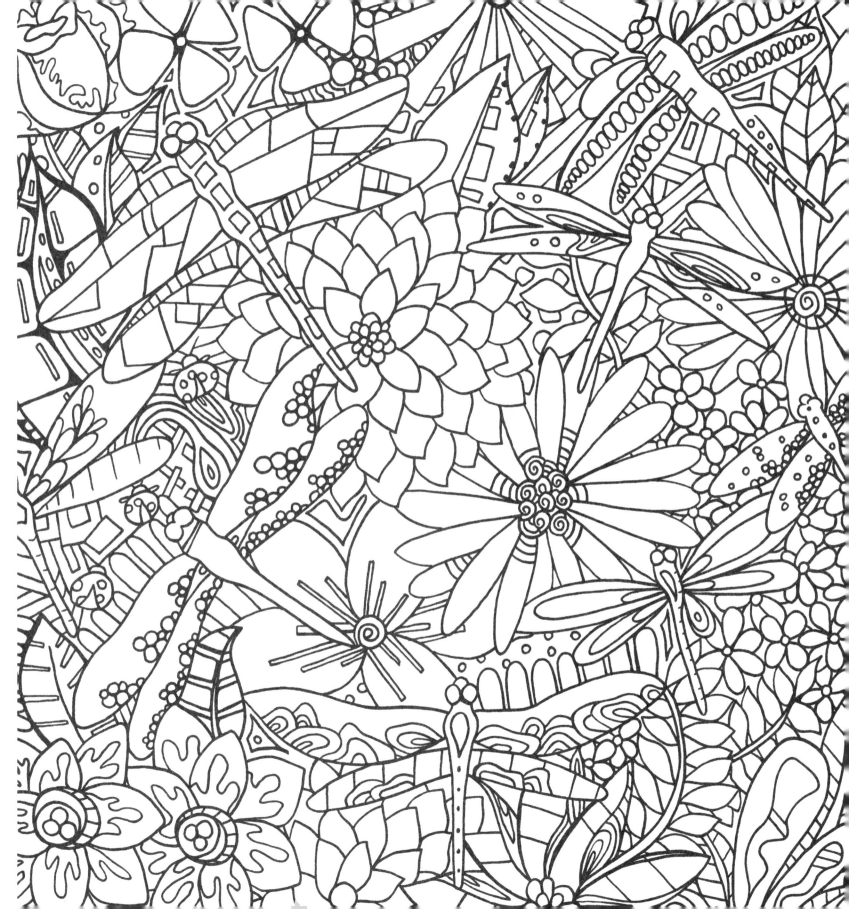

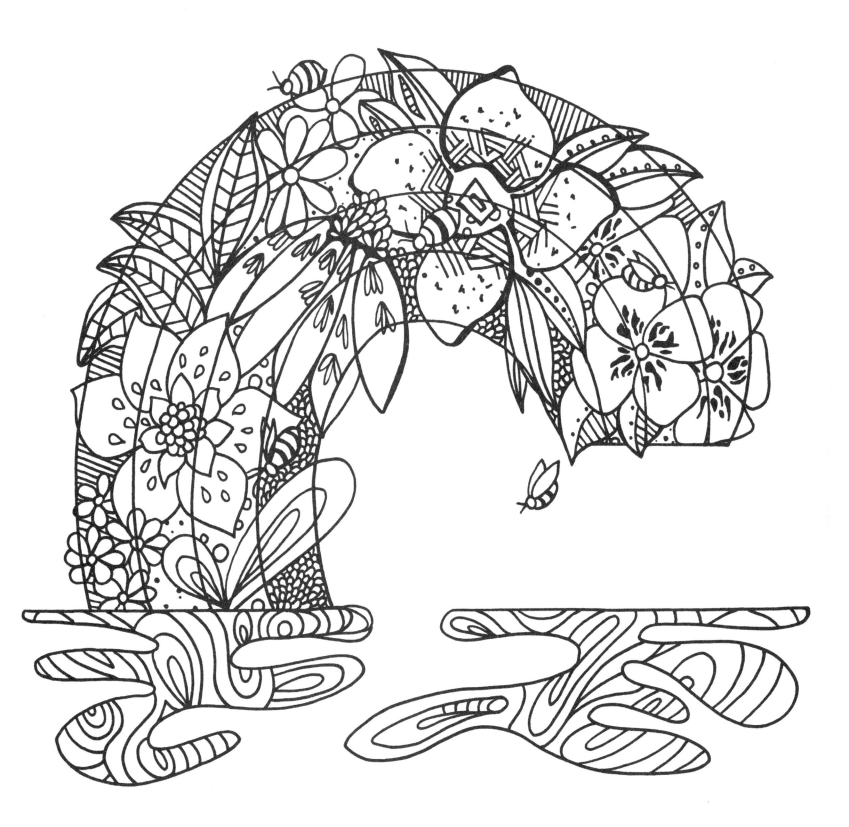

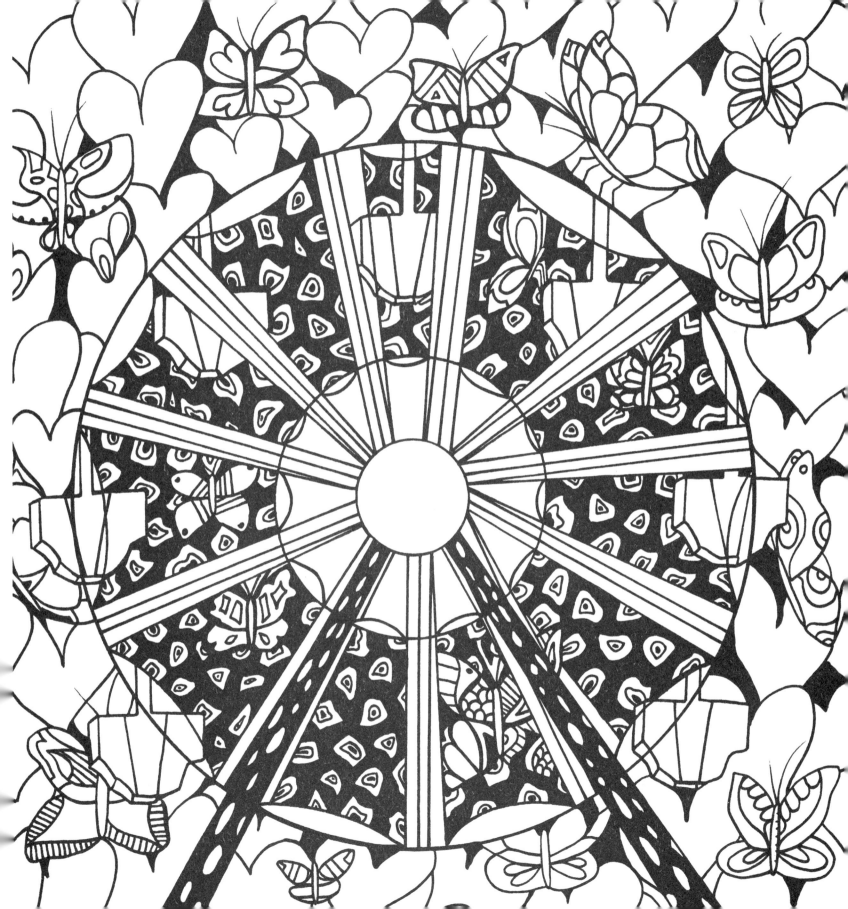

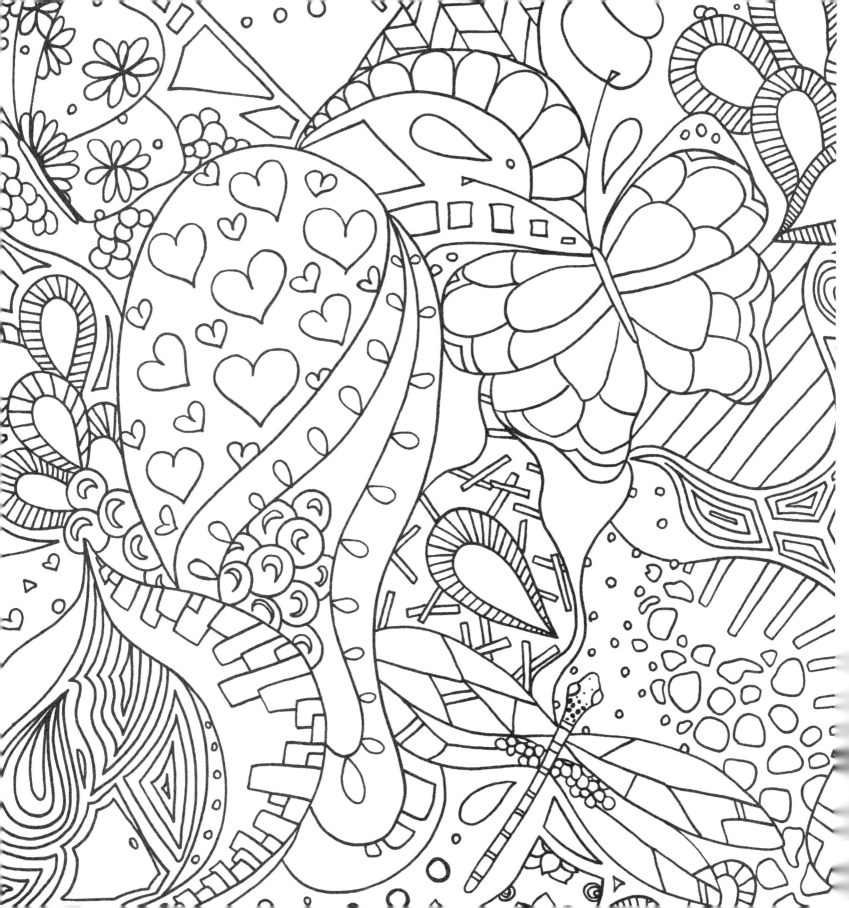

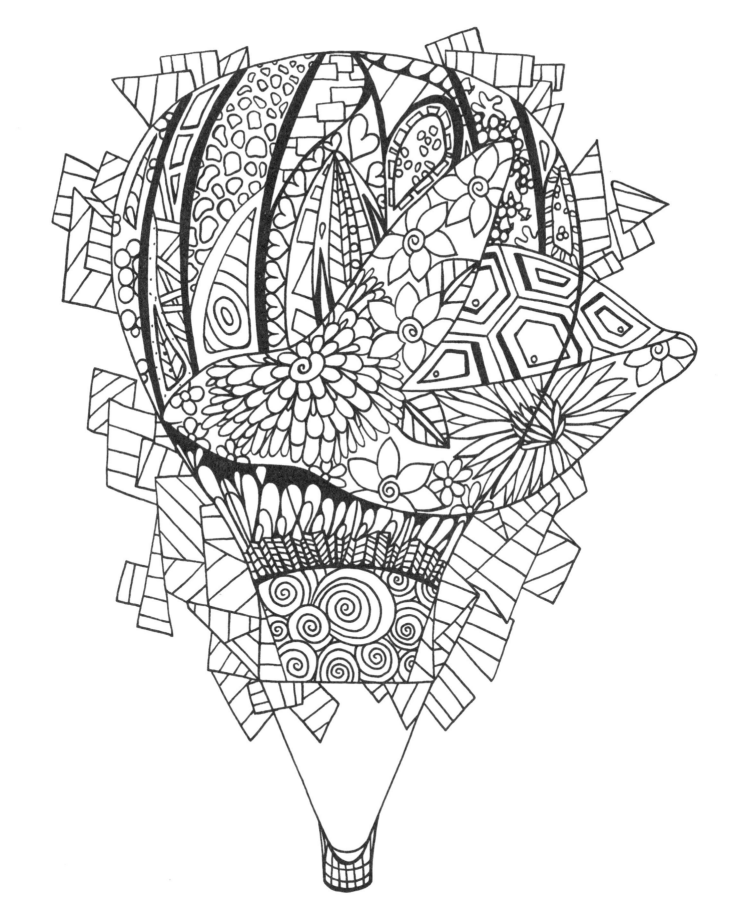

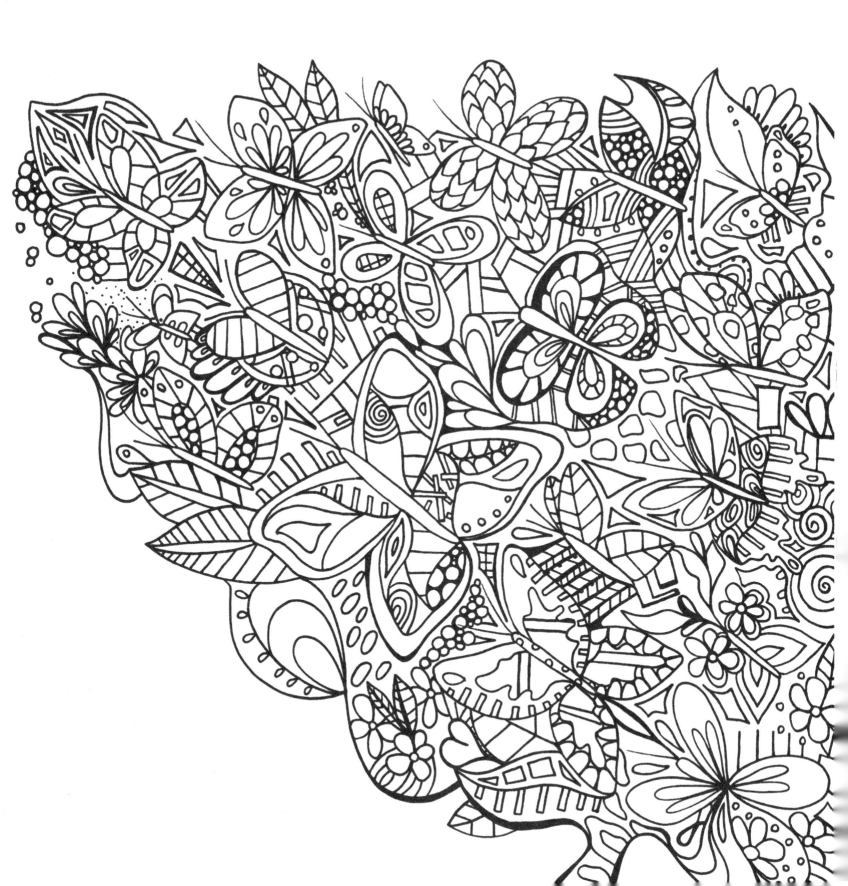

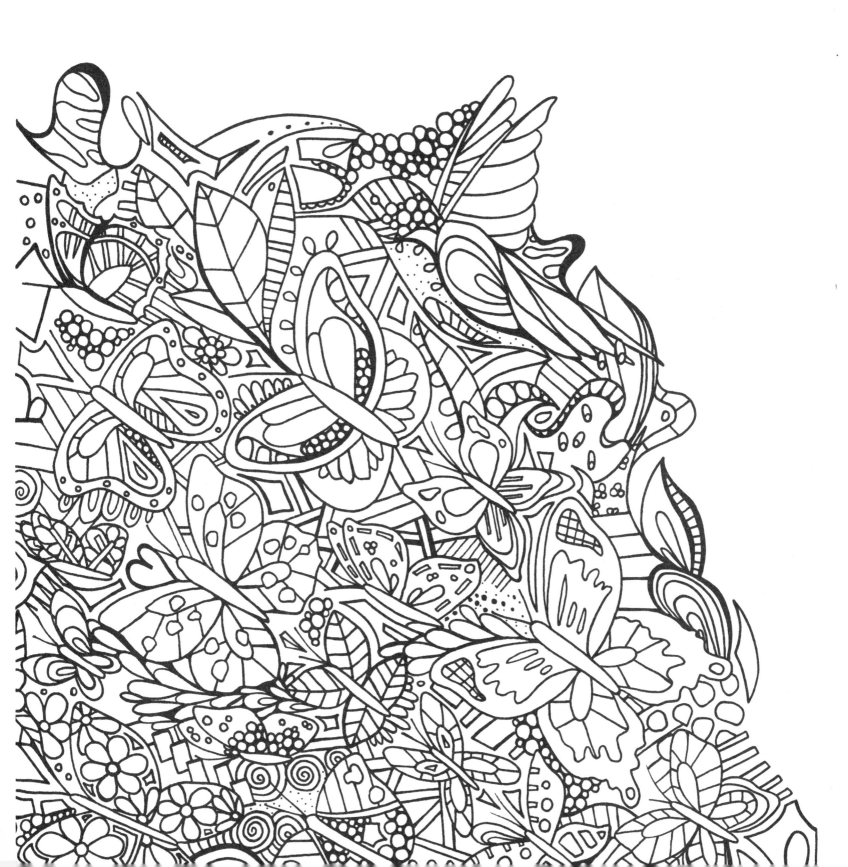

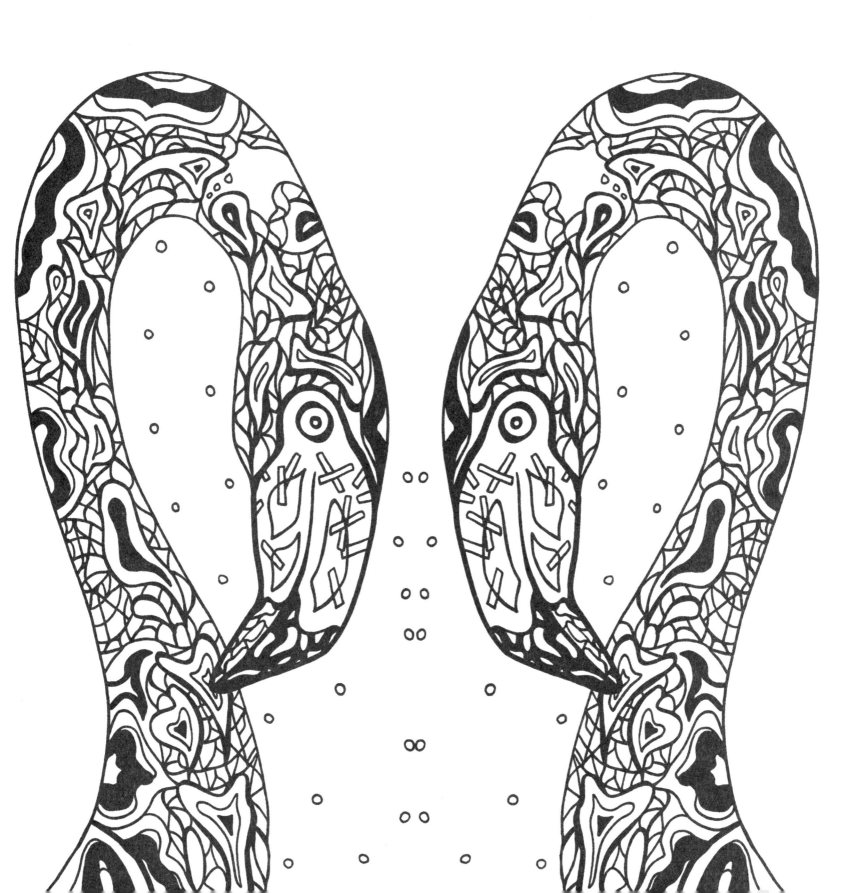

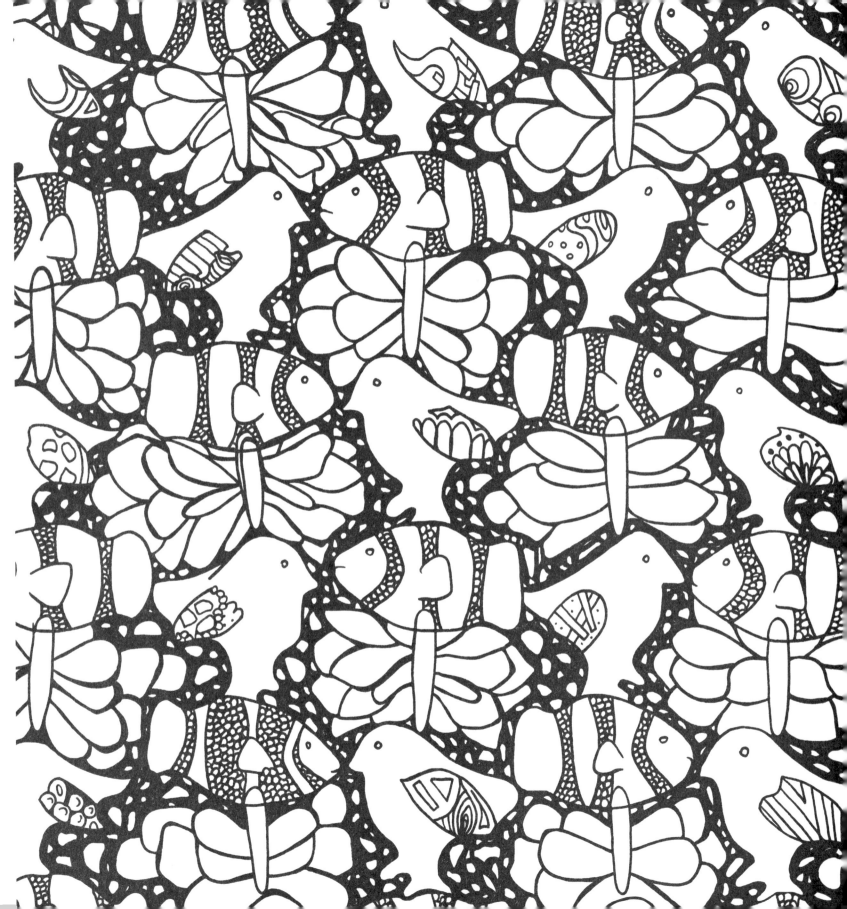

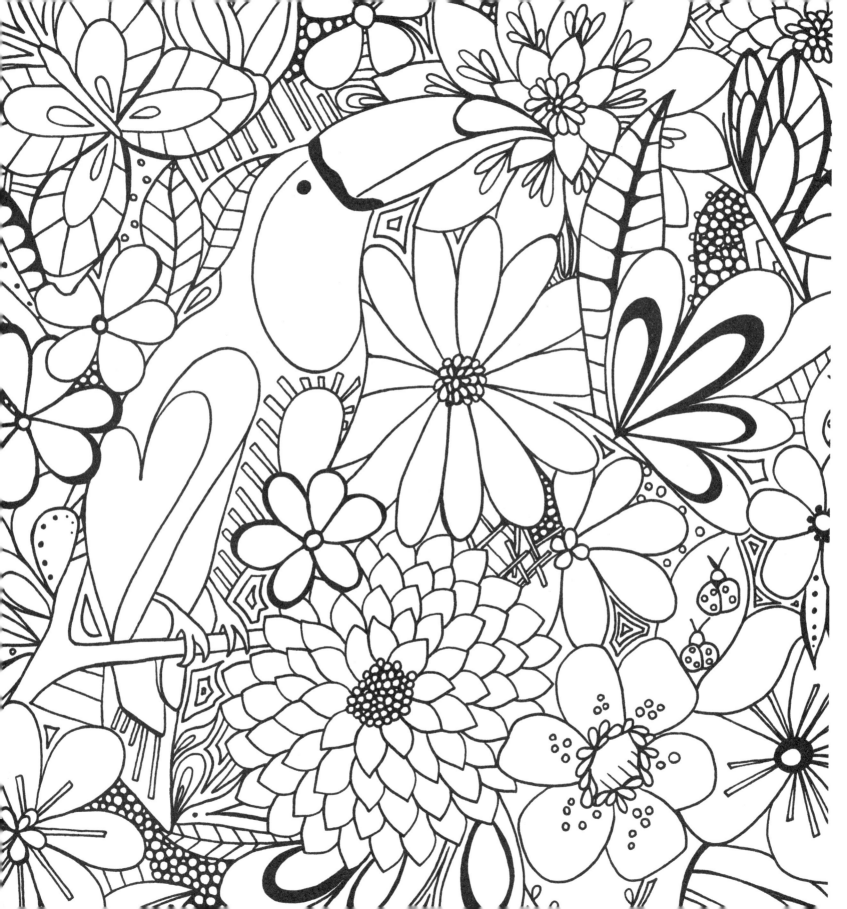

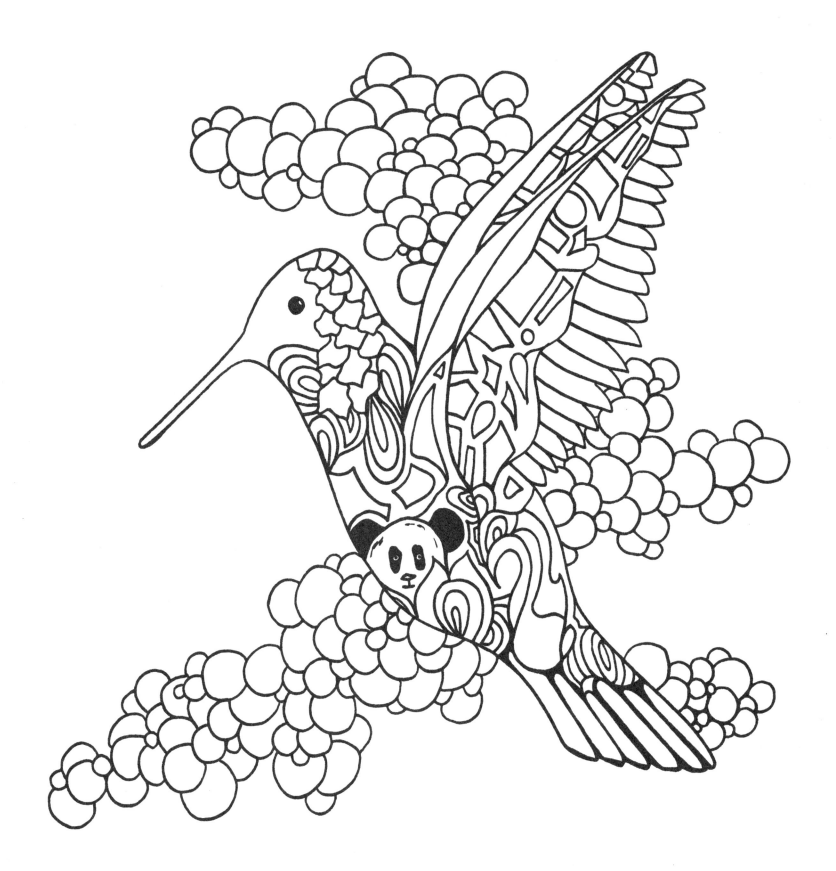

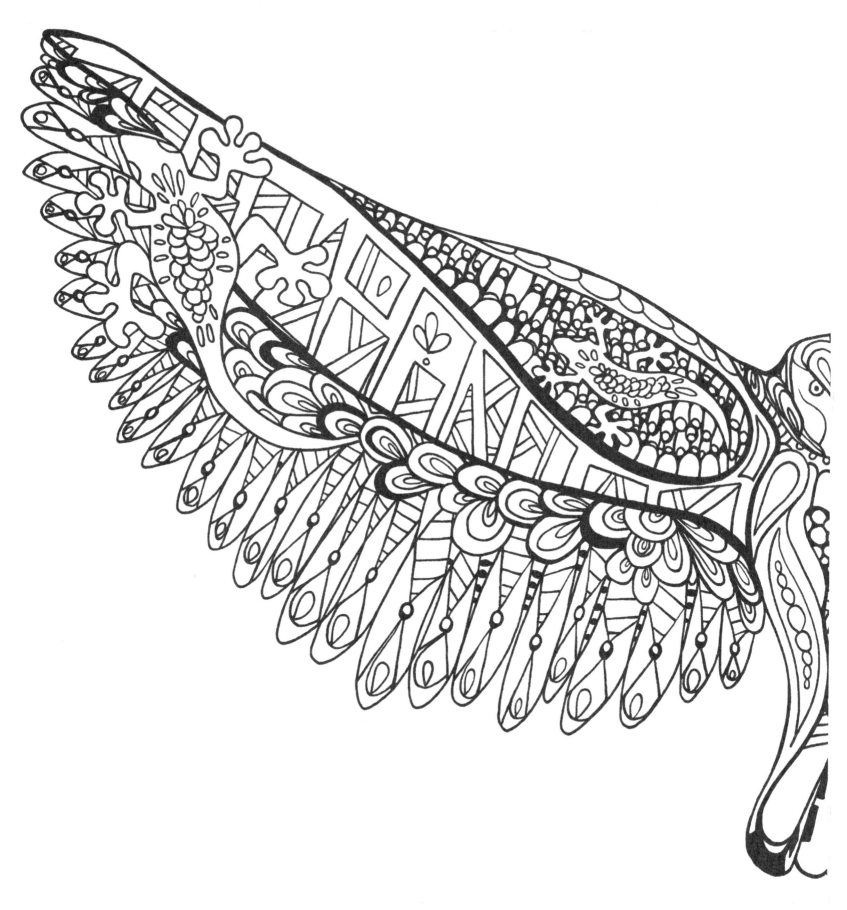

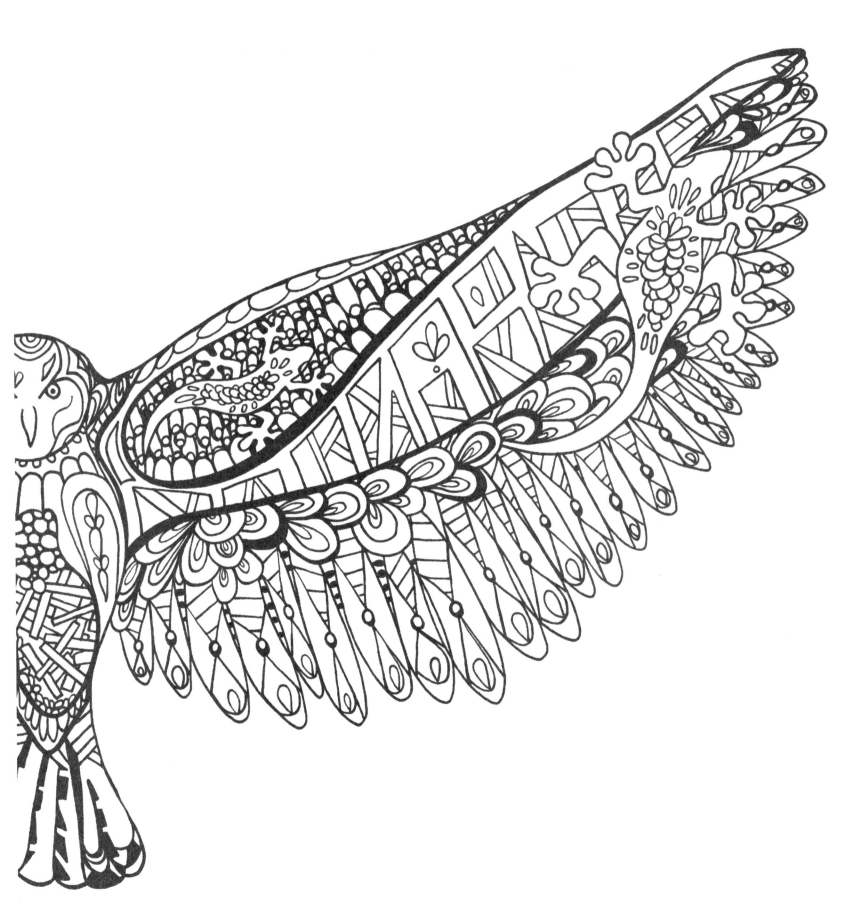

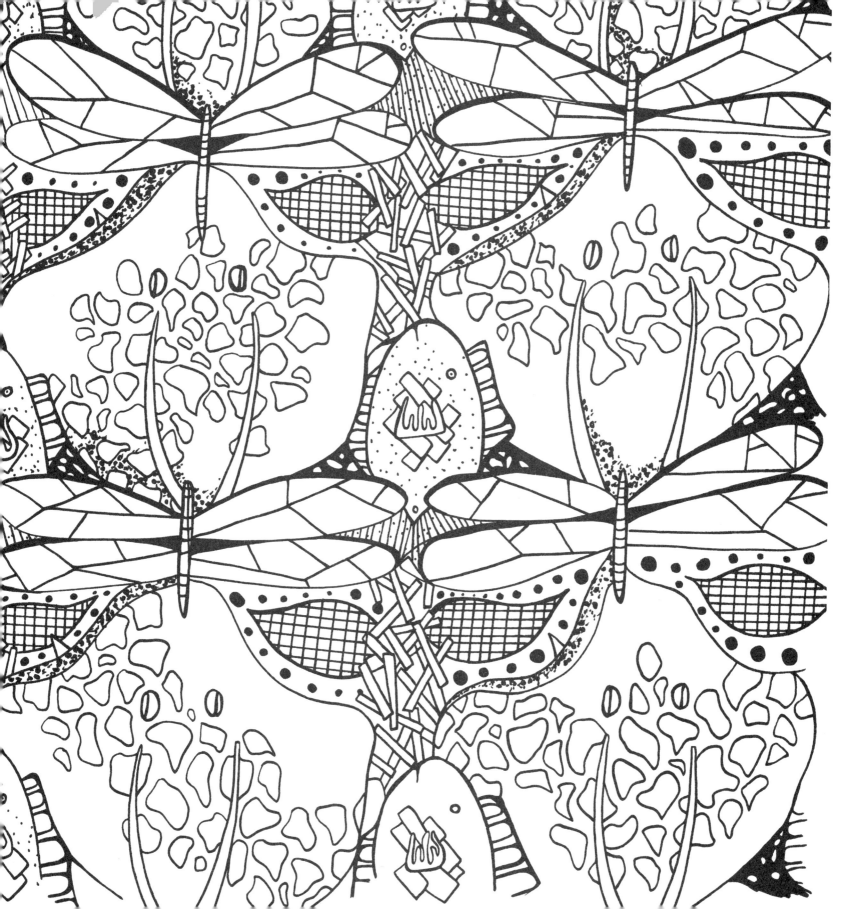

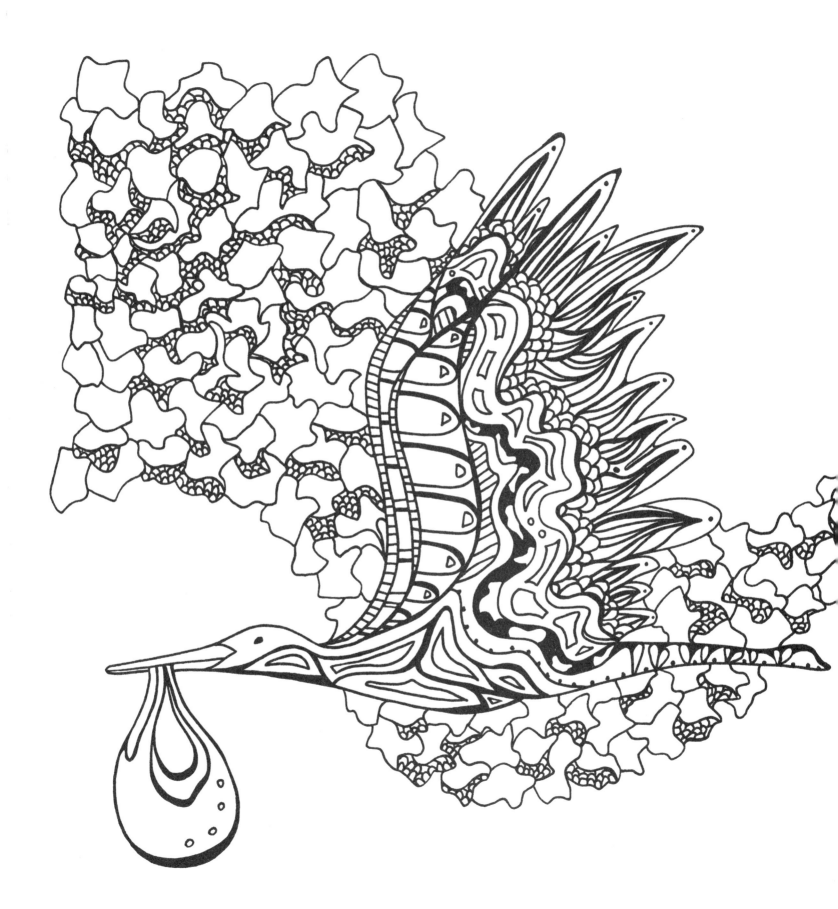

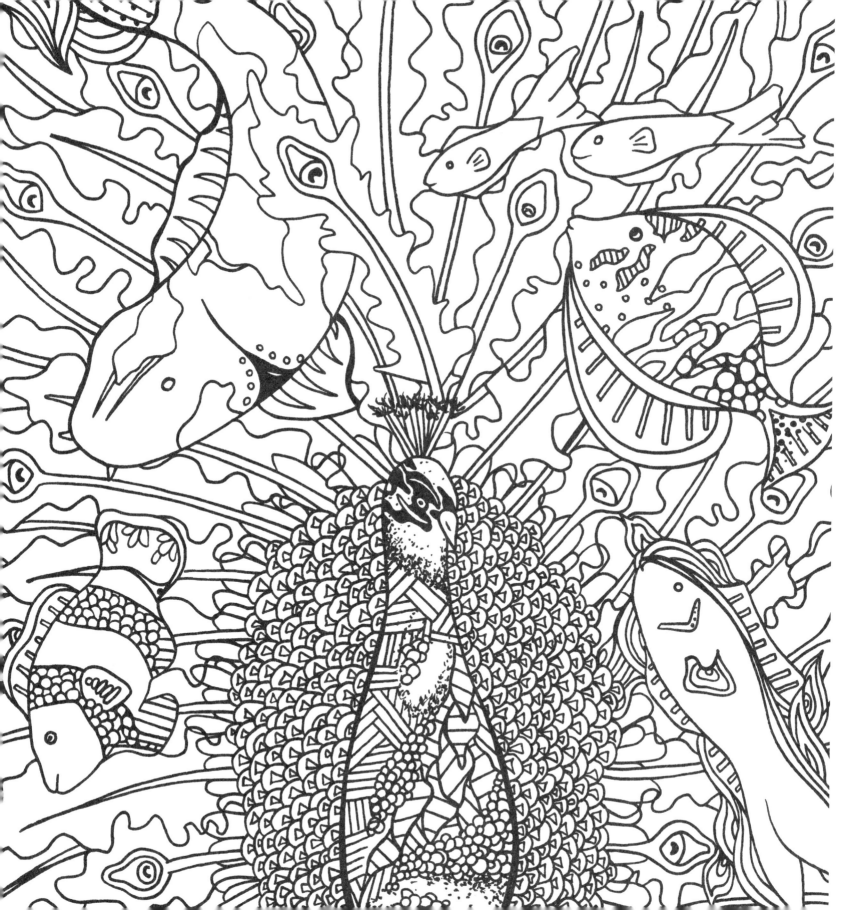

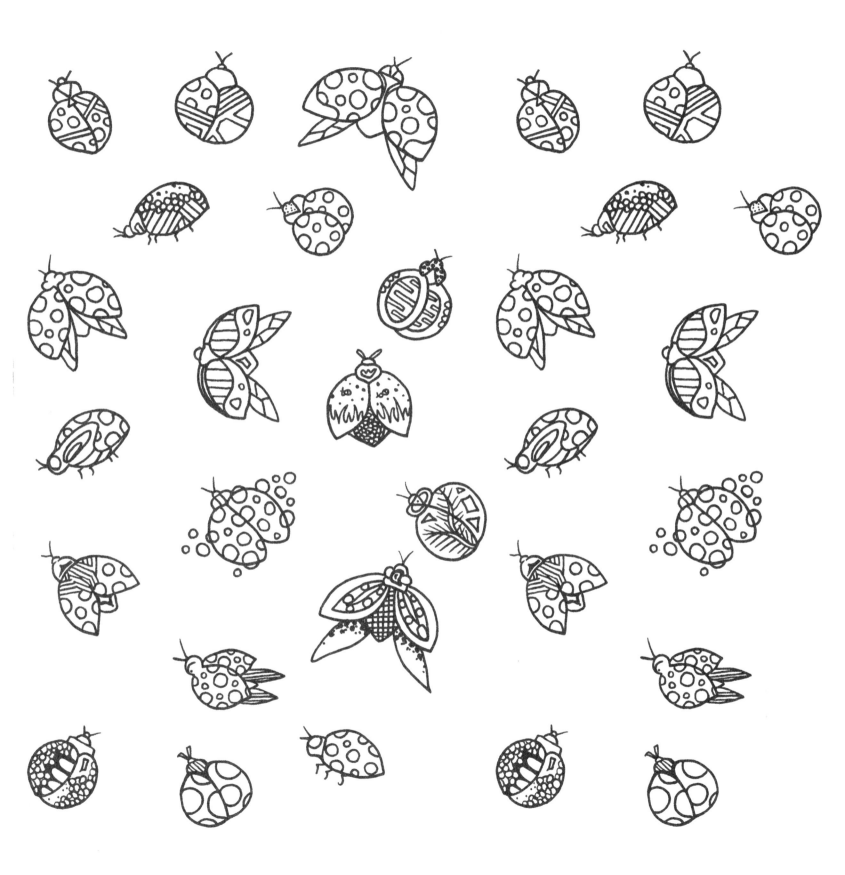

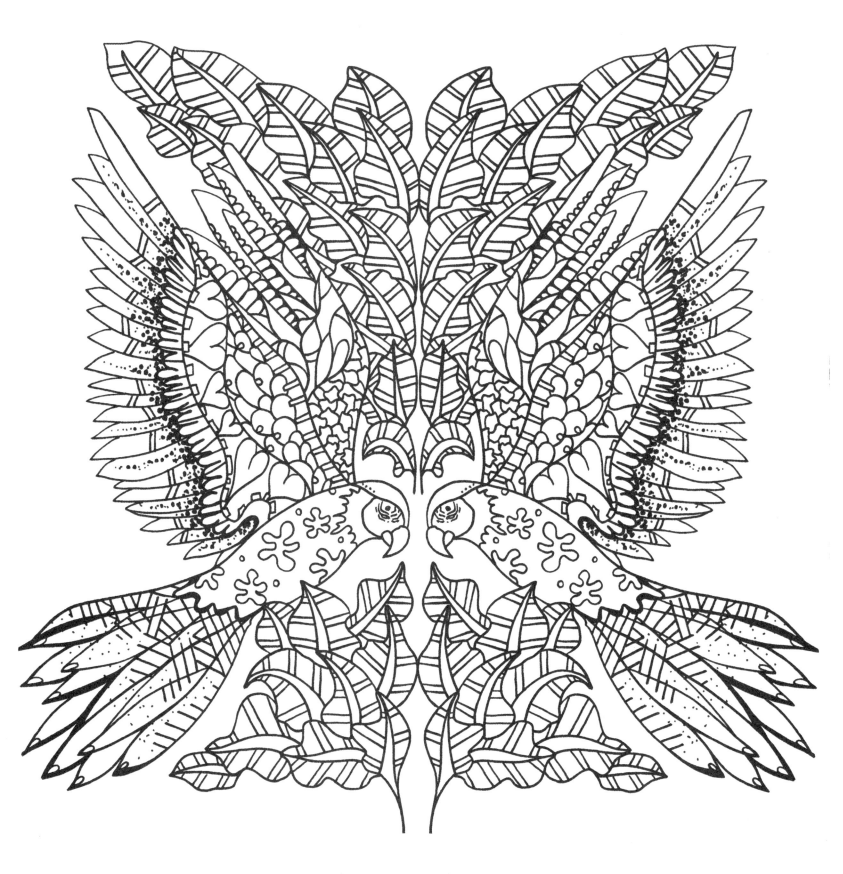

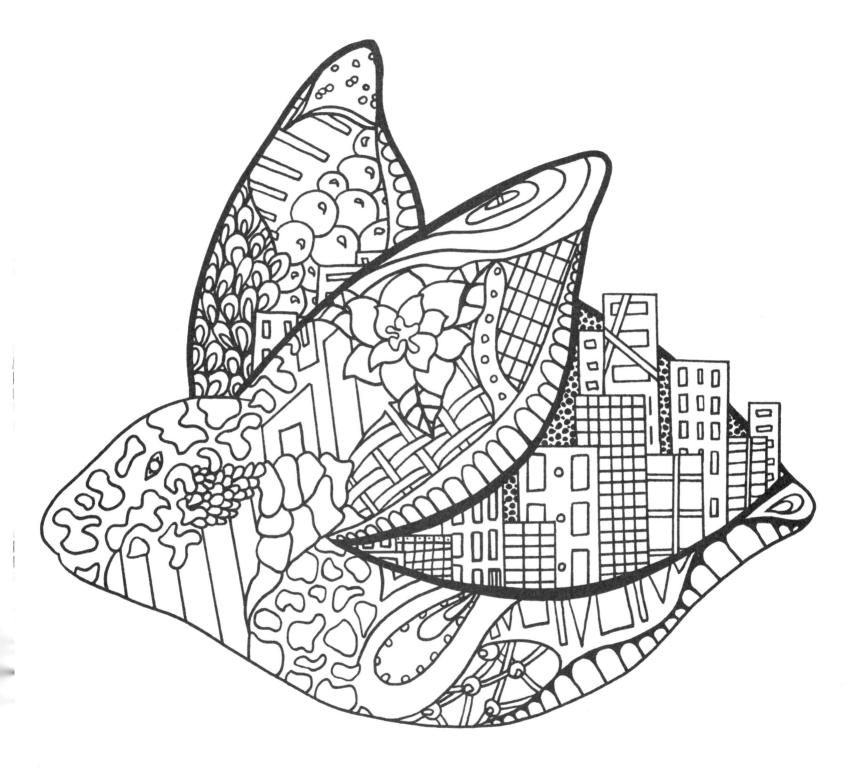

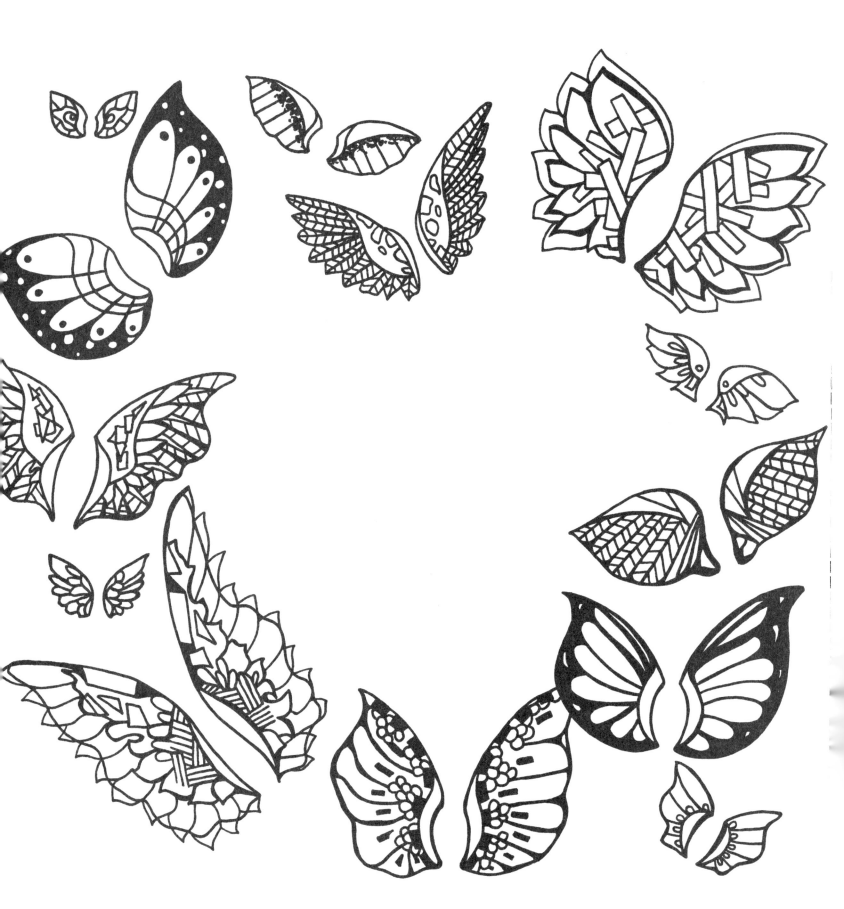

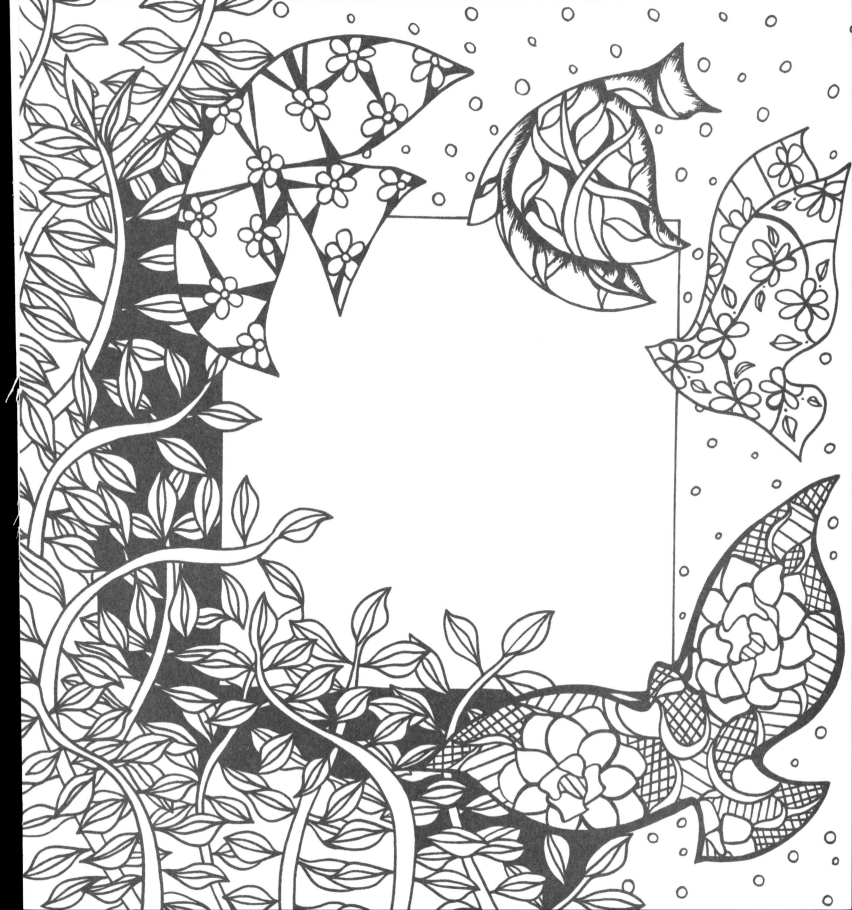

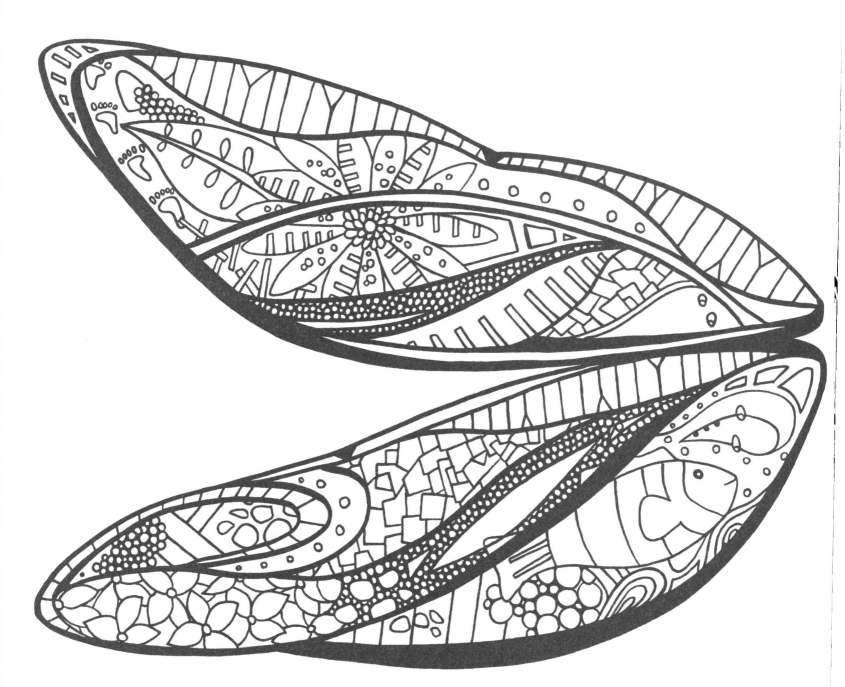

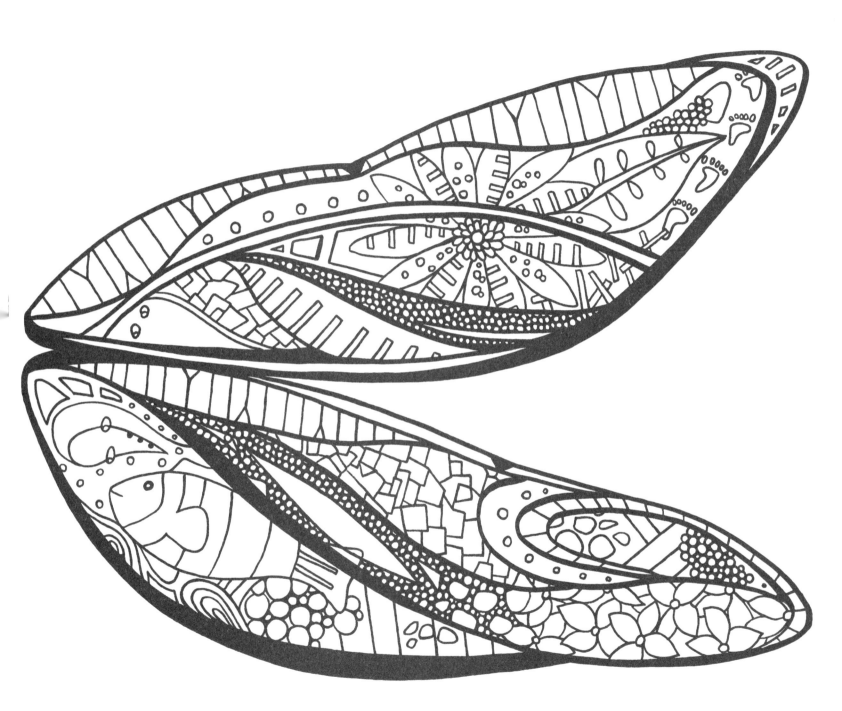

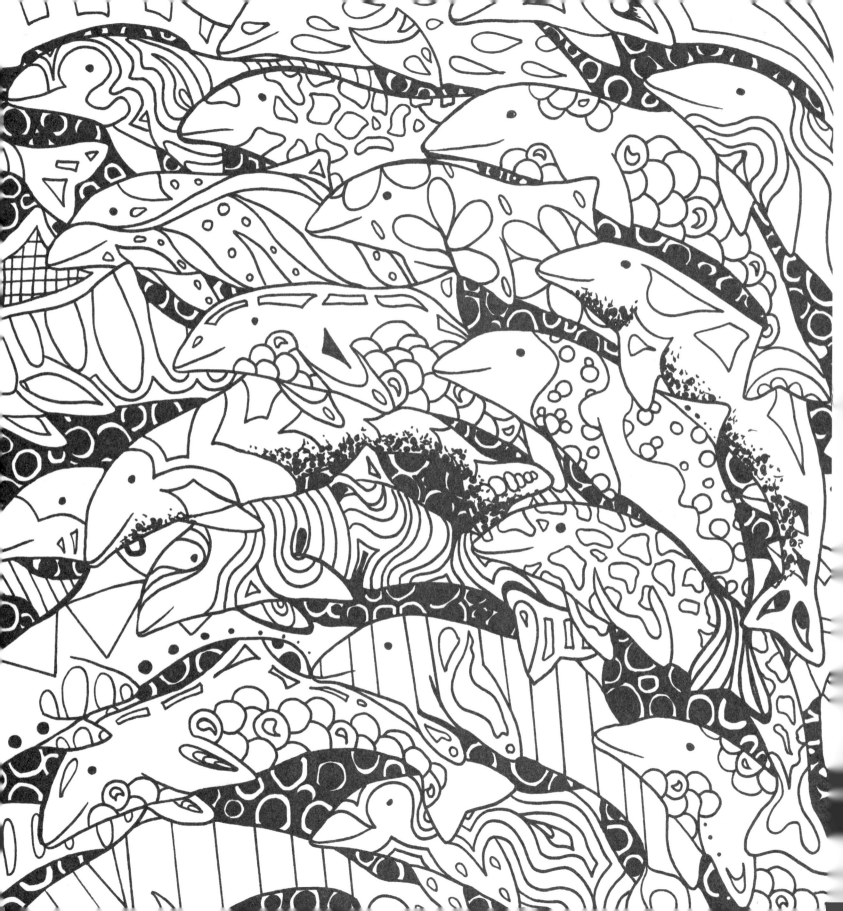

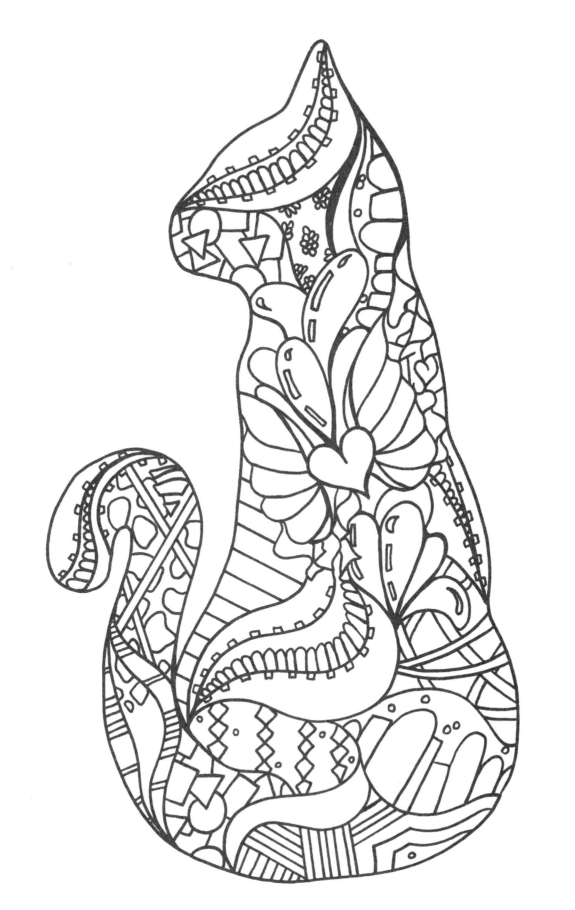

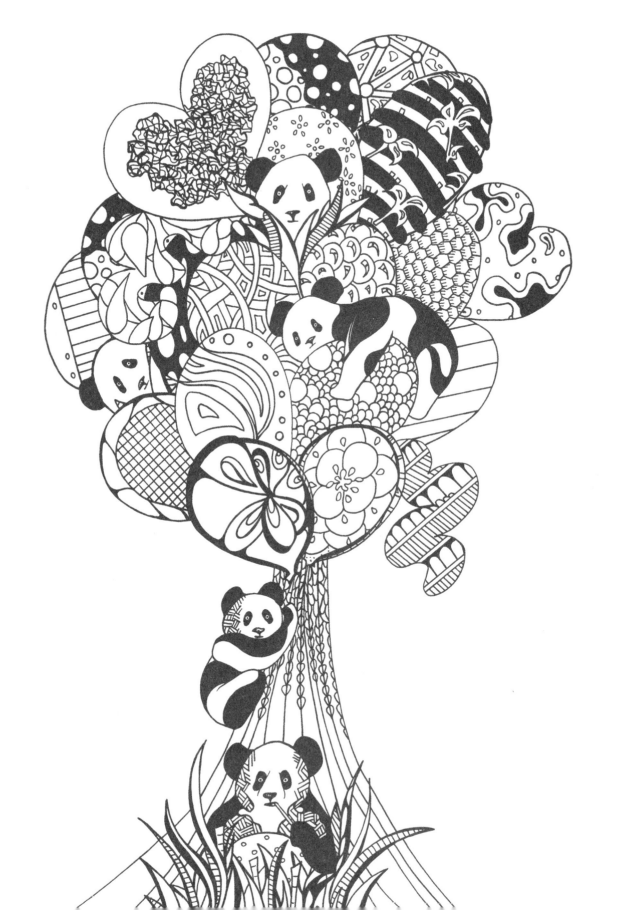

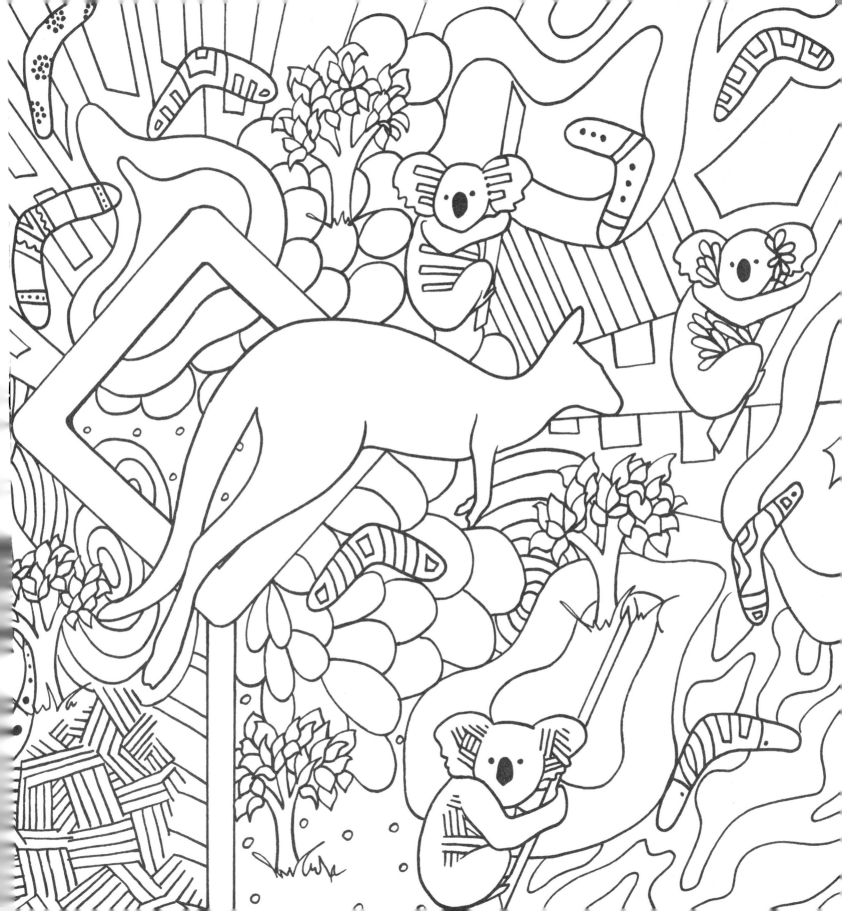

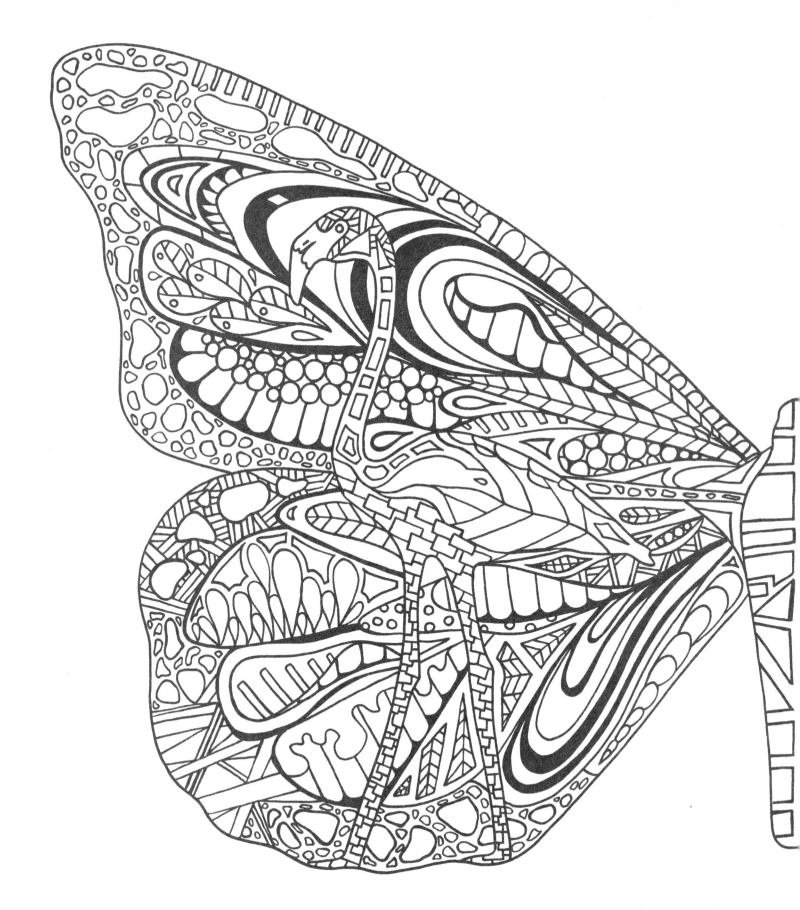

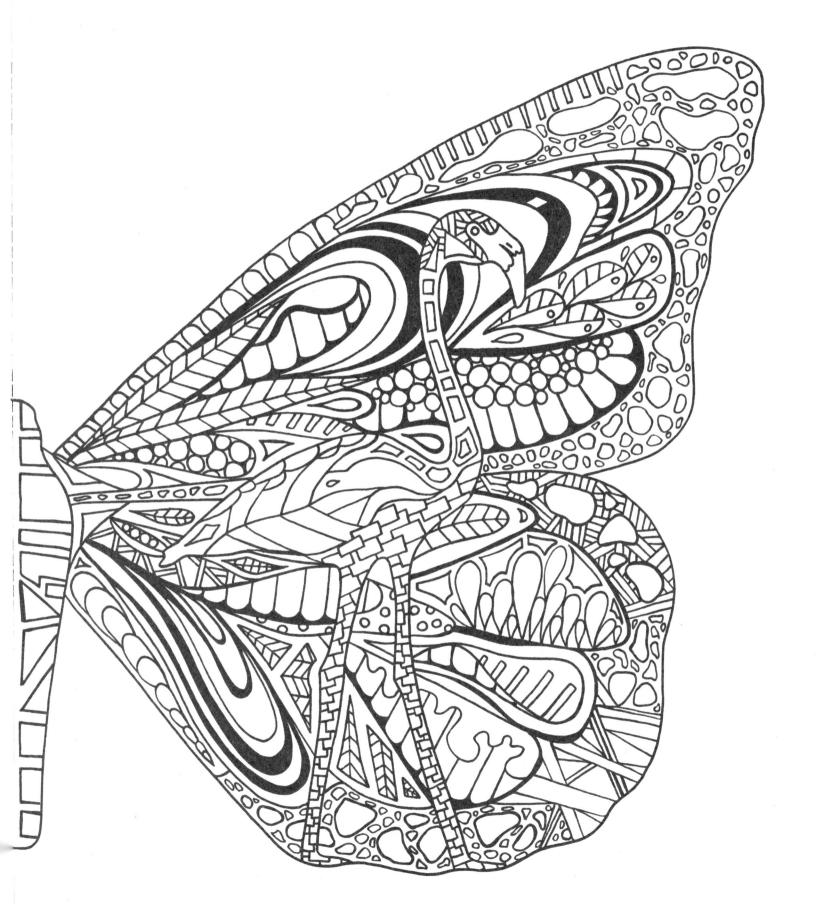

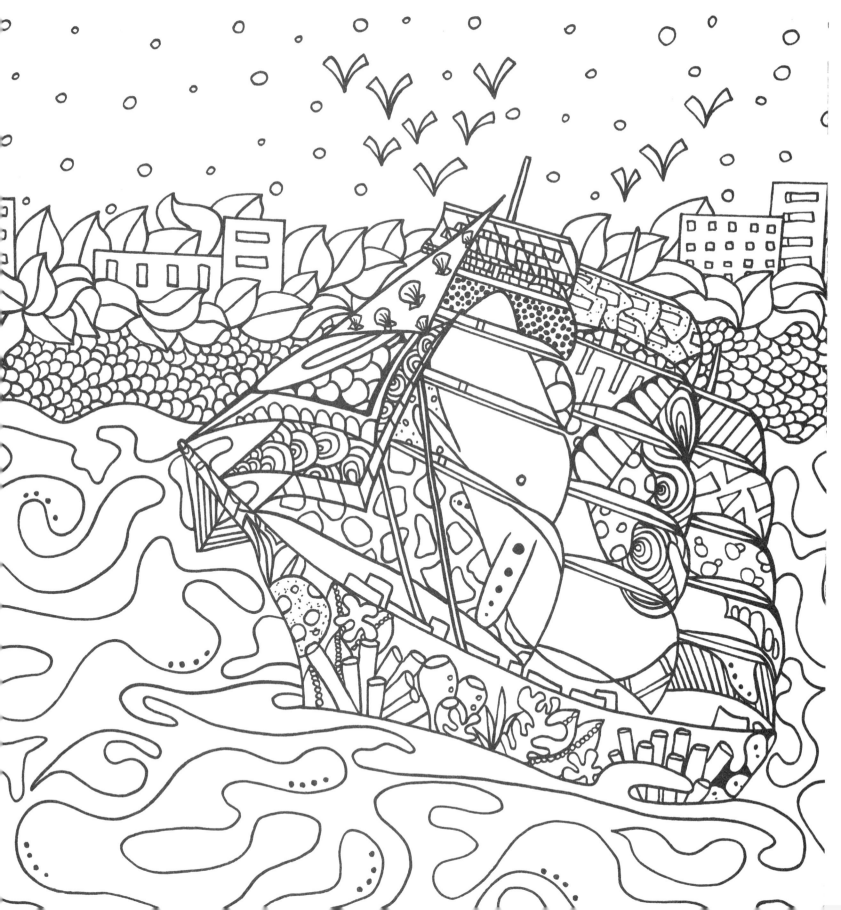

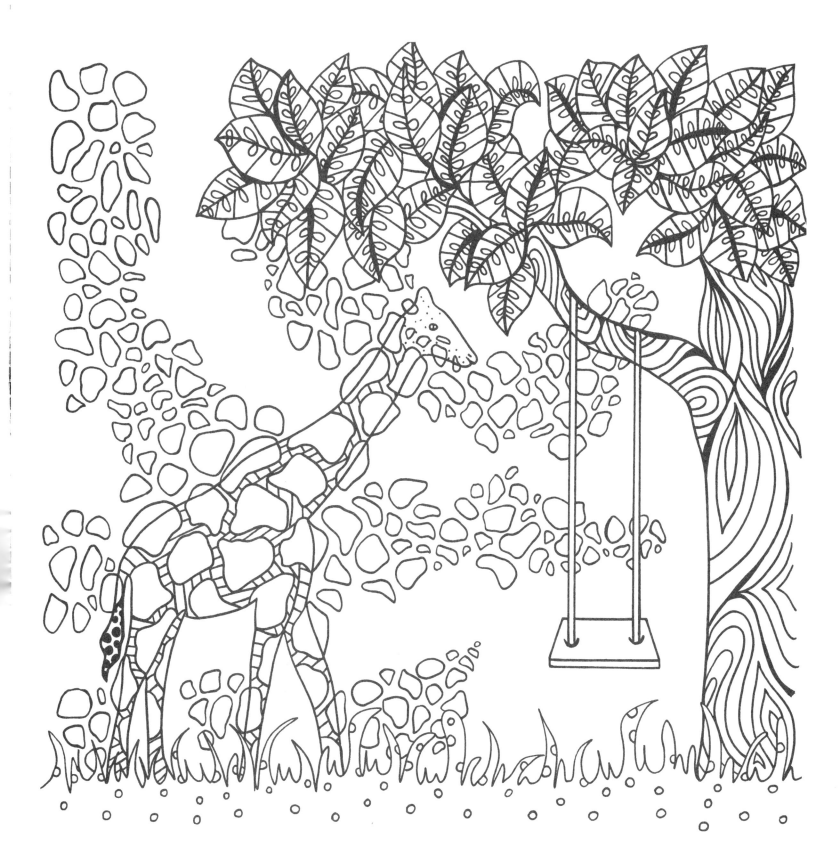

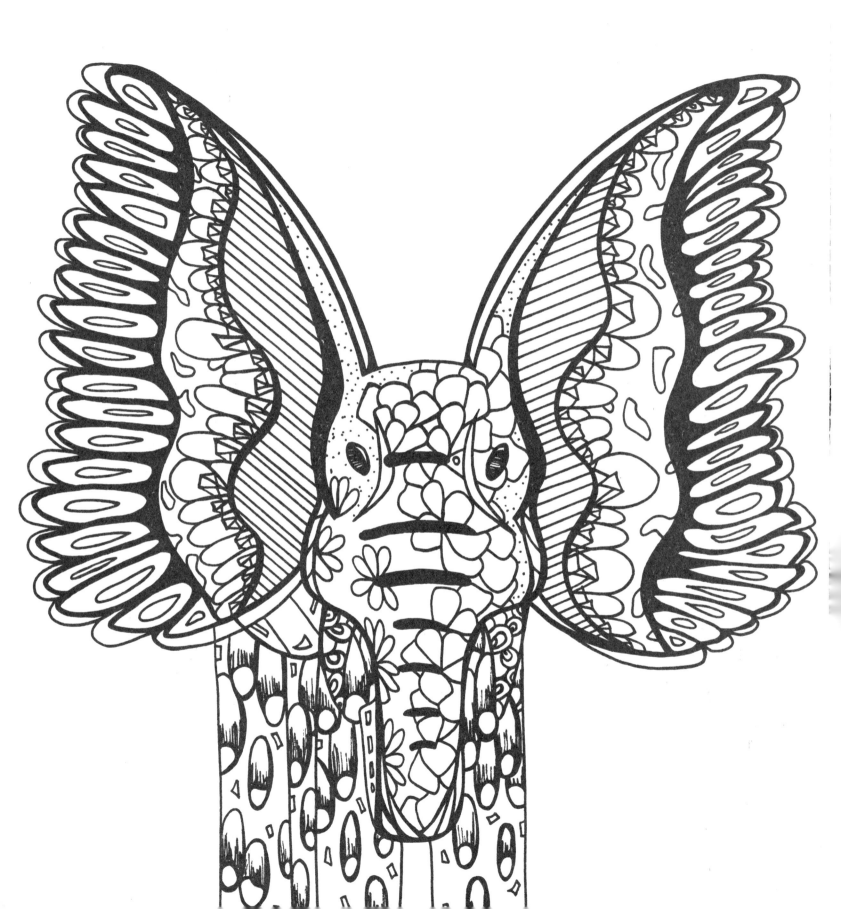

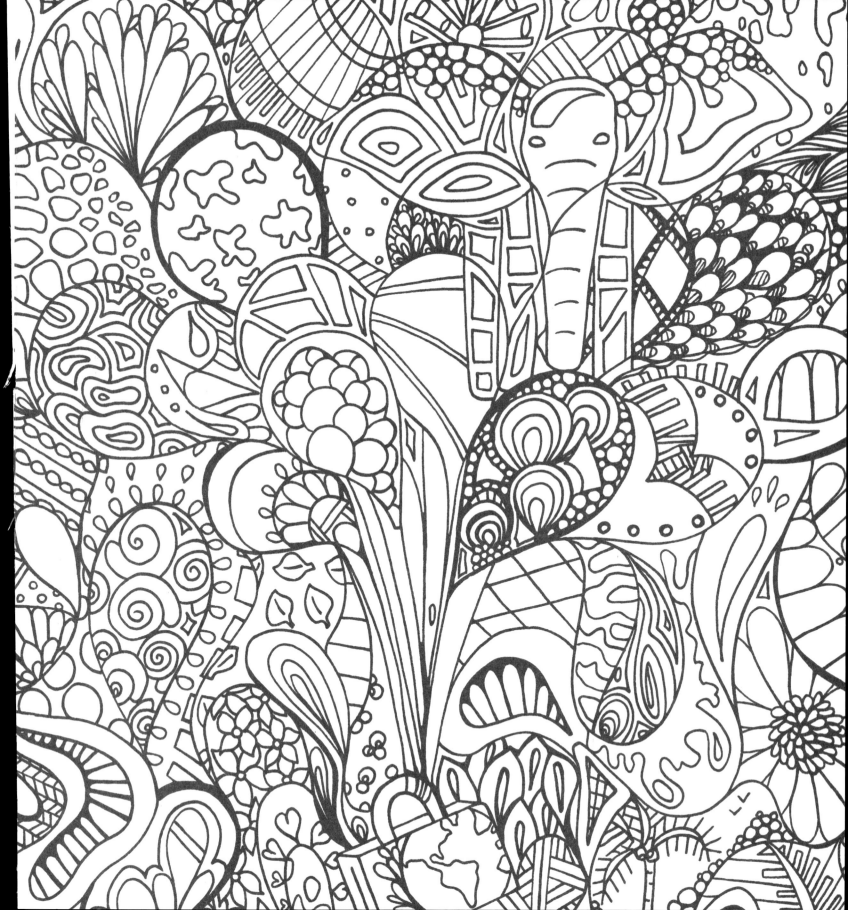

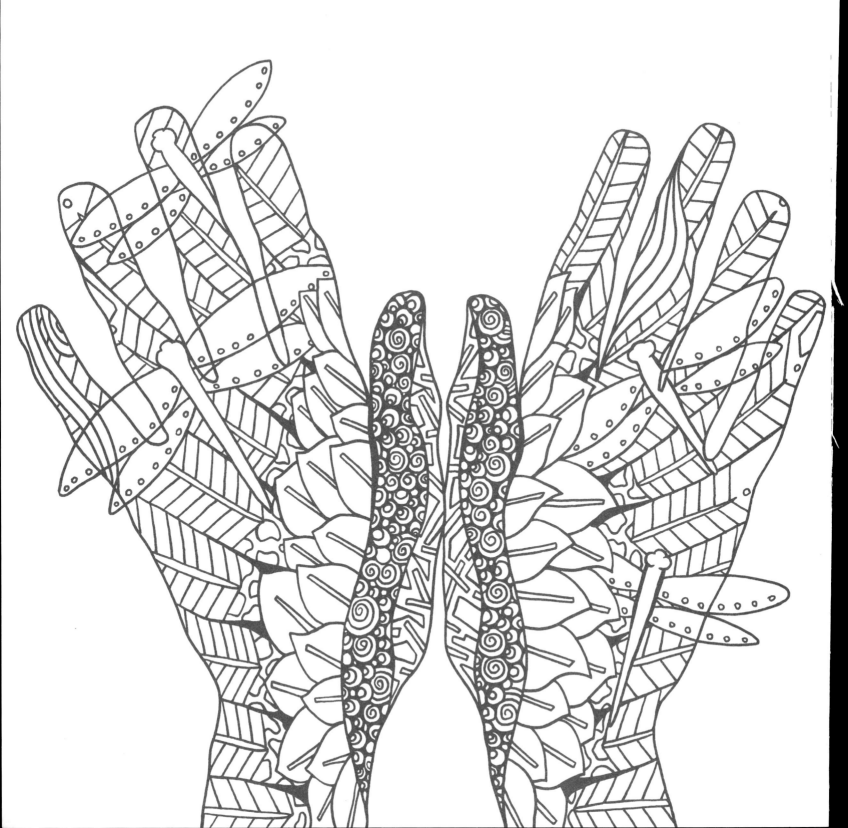

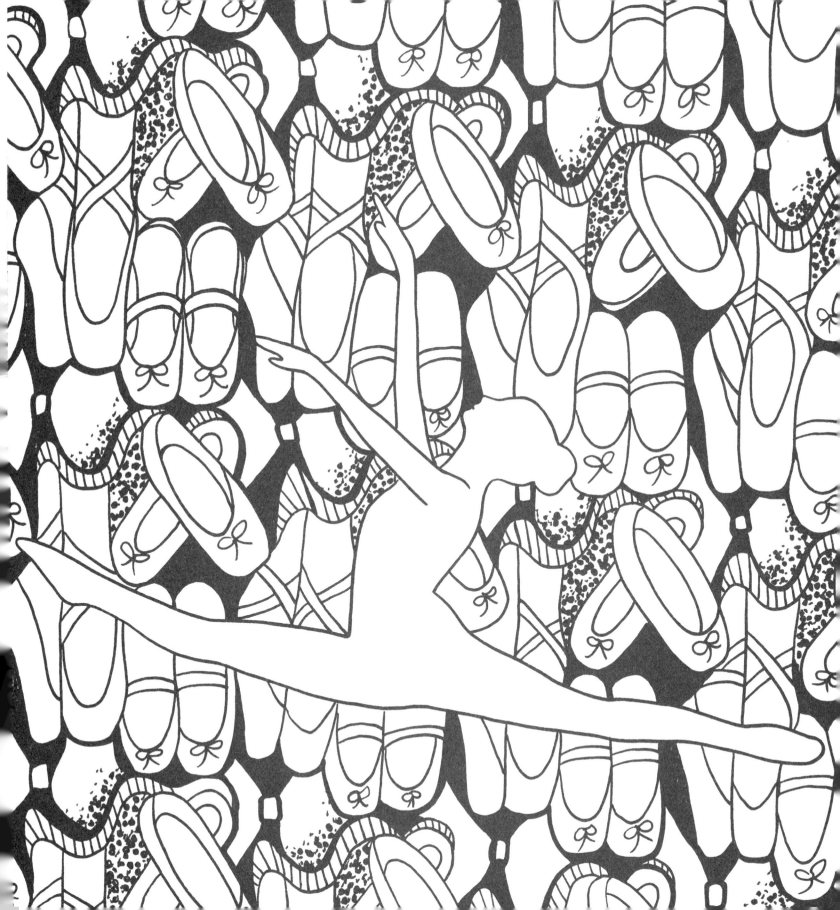

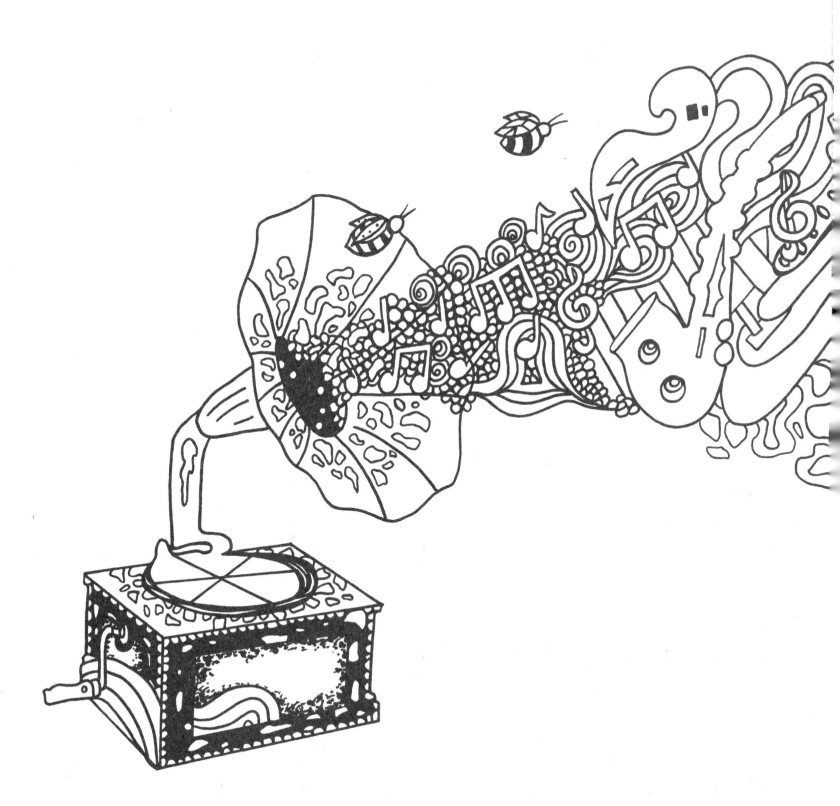

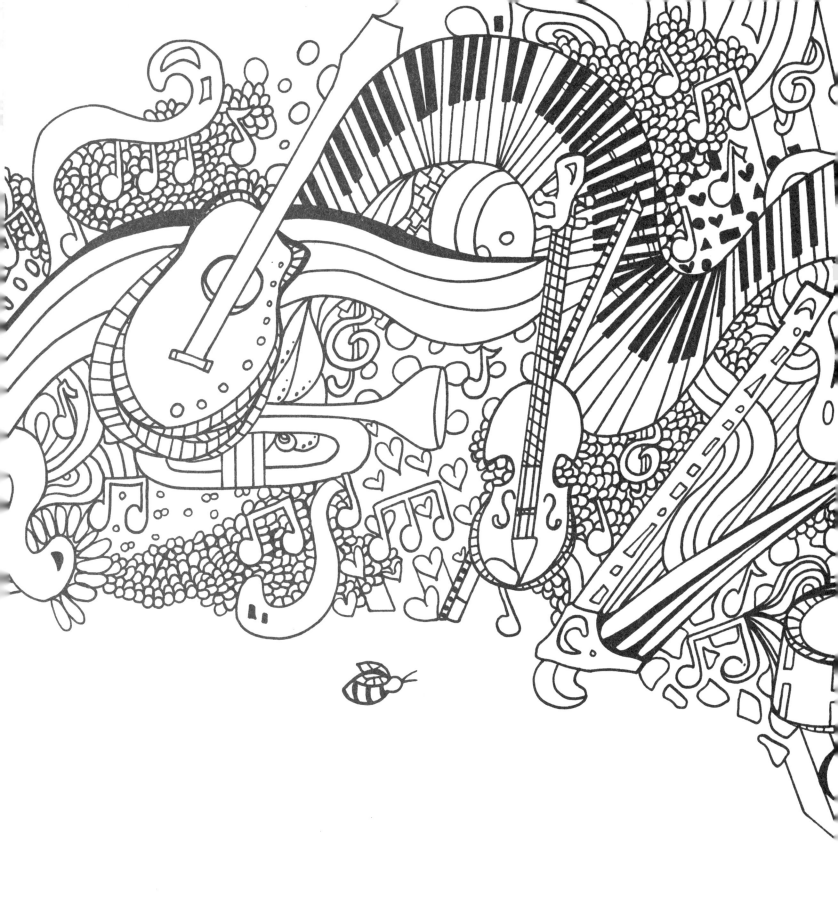

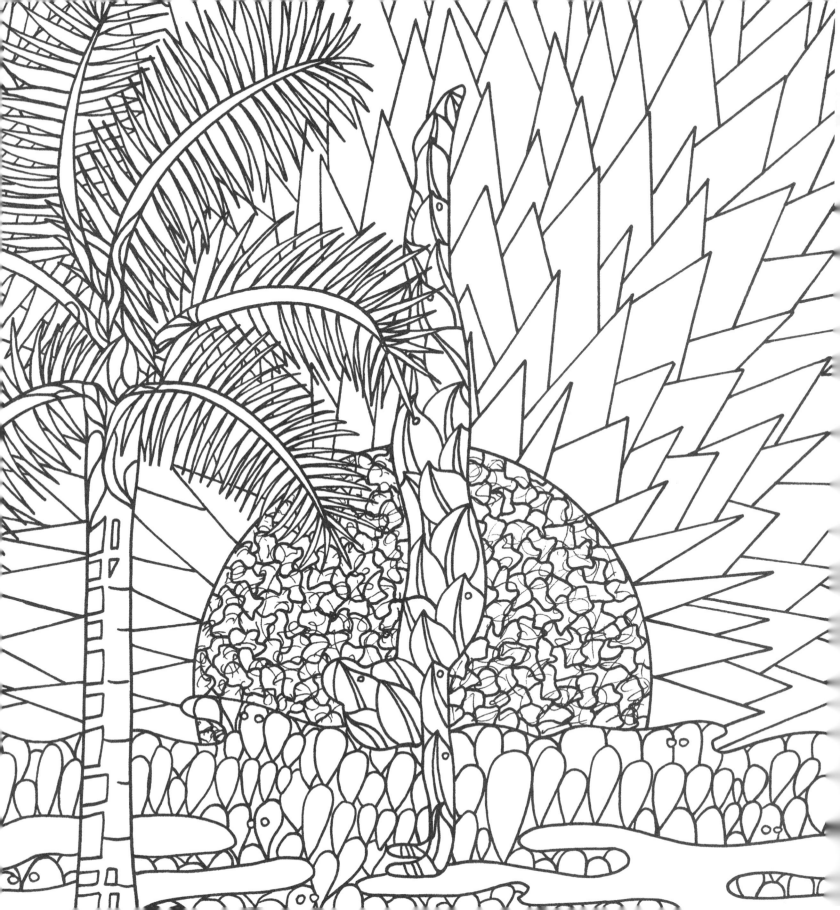

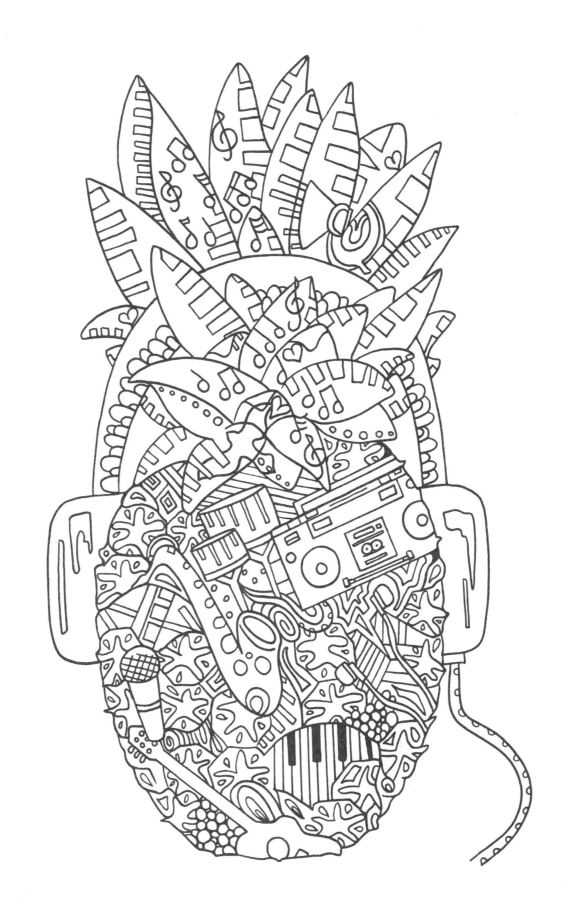

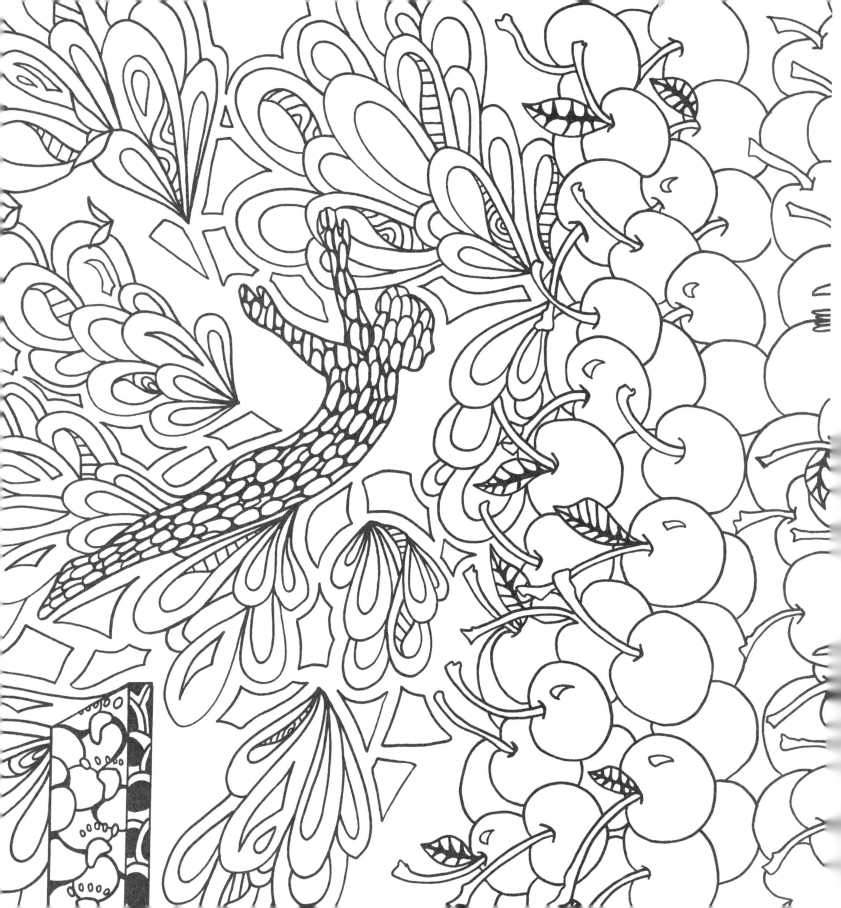

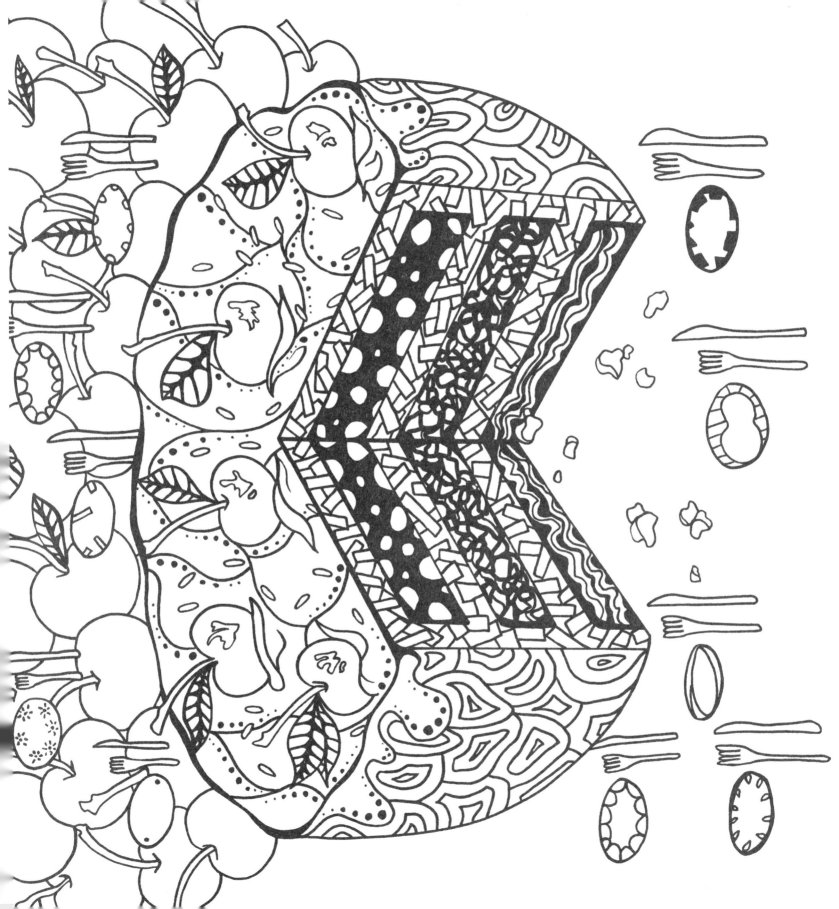

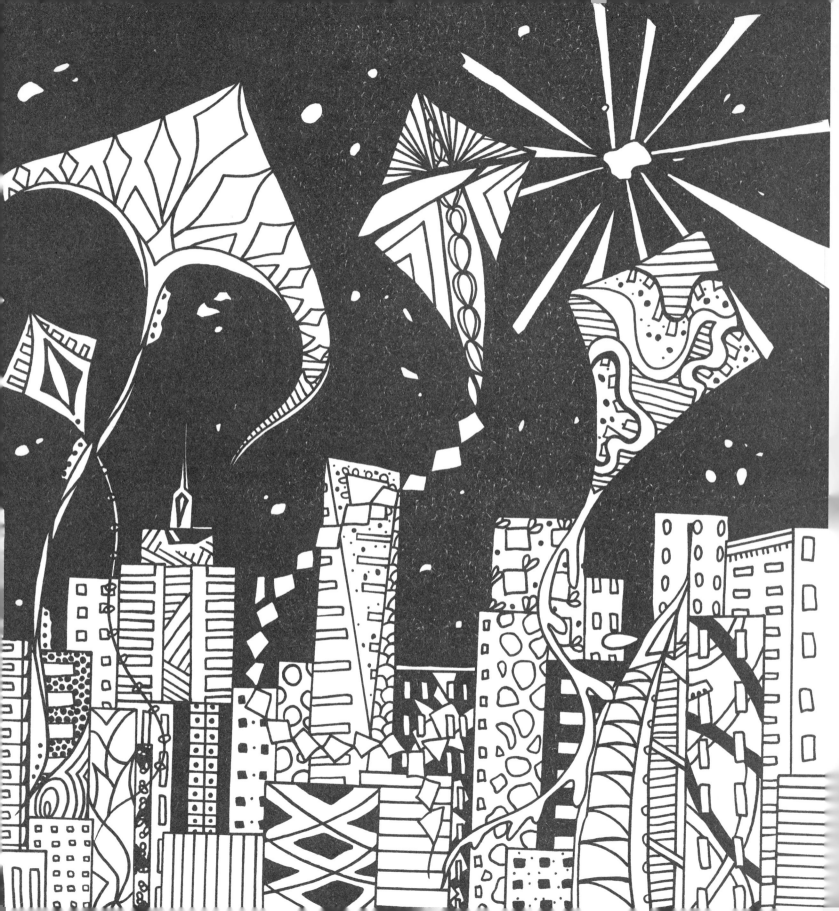

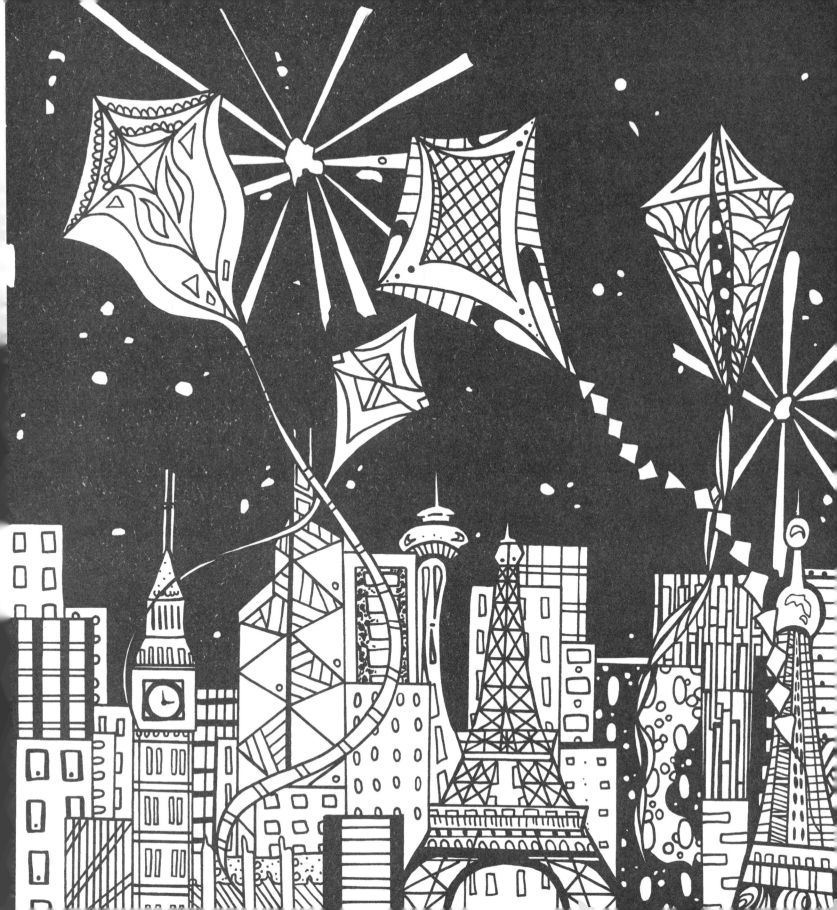

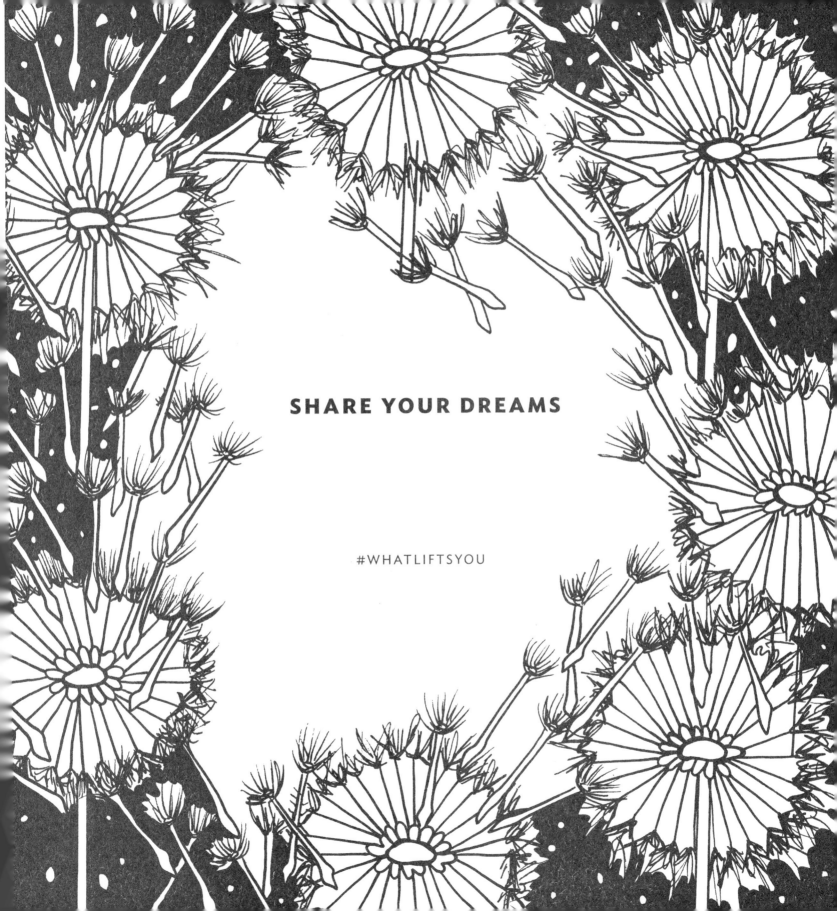

SHARE YOUR DREAMS

#WHATLIFTSYOU

WHO GIVES YOU WINGS? _____

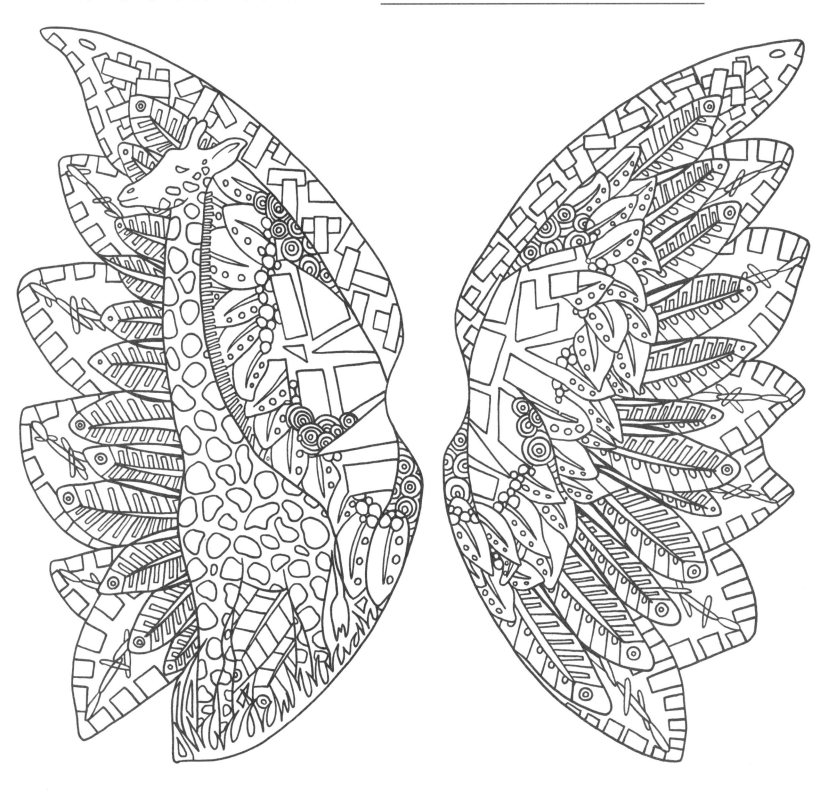

WHAT IS YOUR FAVORITE CITY? _____

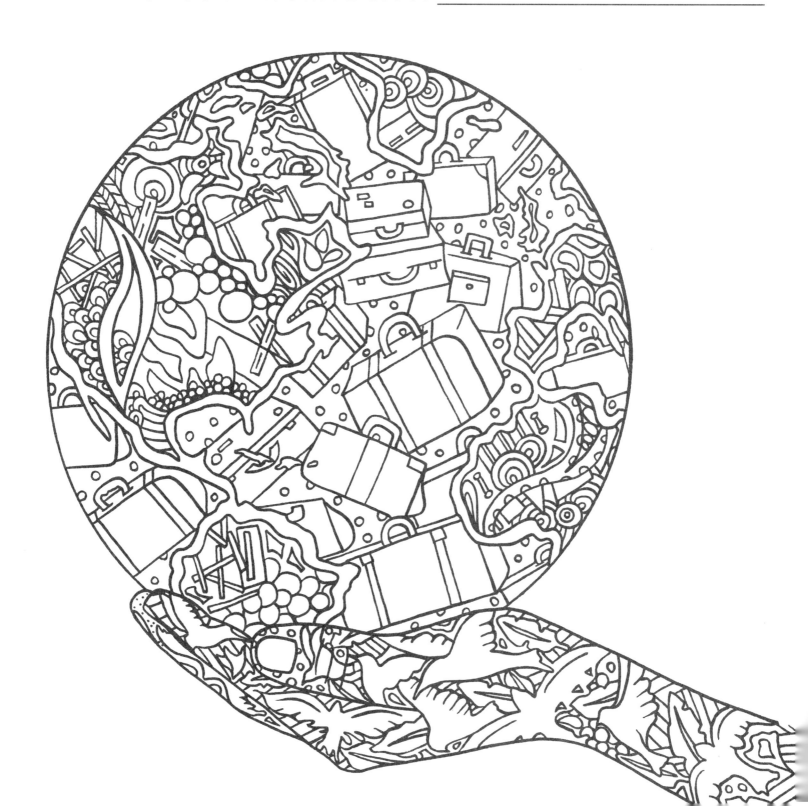

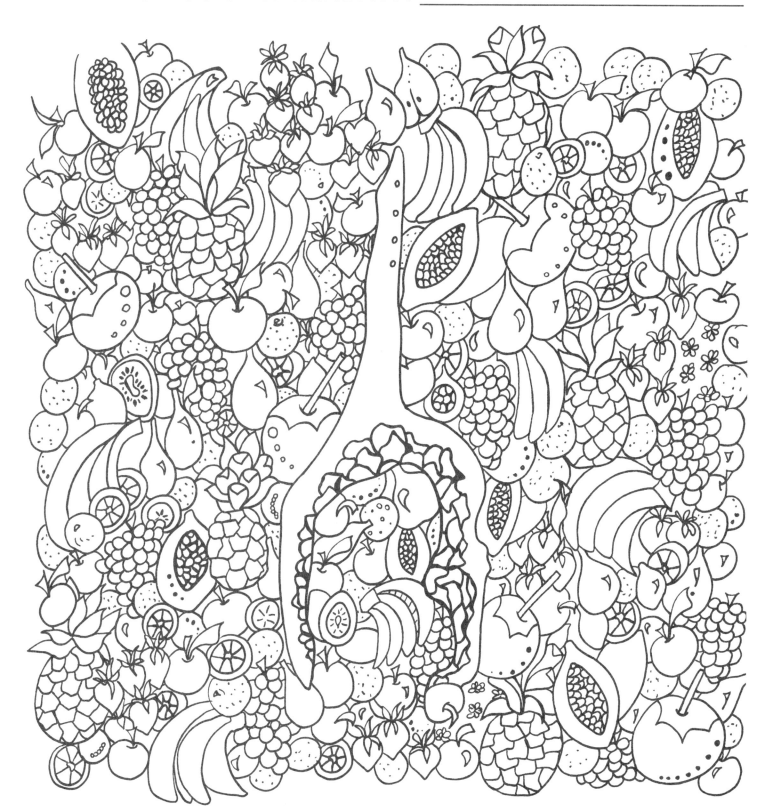

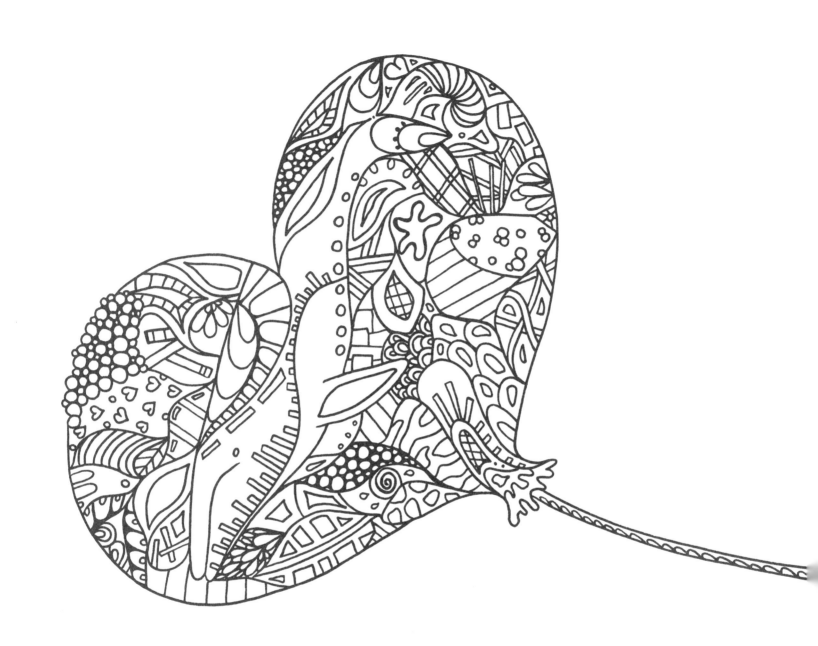

WHAT TUGS AT YOUR HEART? _____

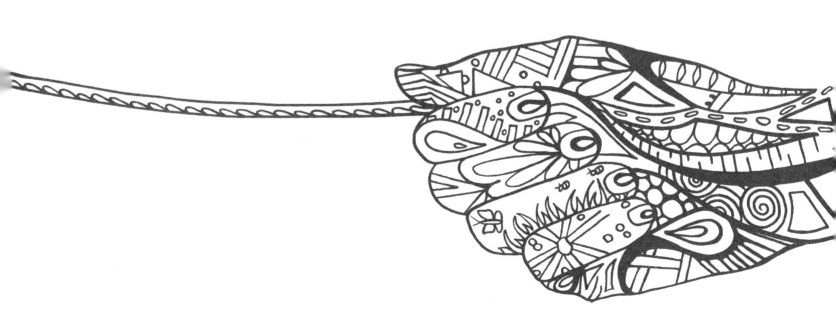

WHAT DO YOU CELEBRATE? _____

WHAT'S YOUR WISH THIS YEAR? _____

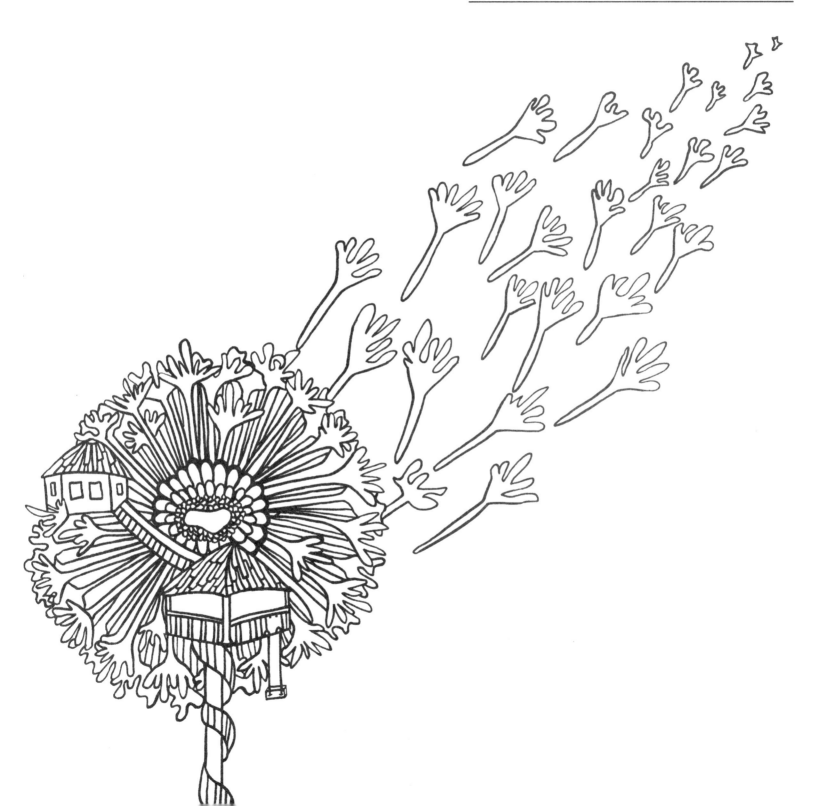

WHAT SETS YOU FREE? _____

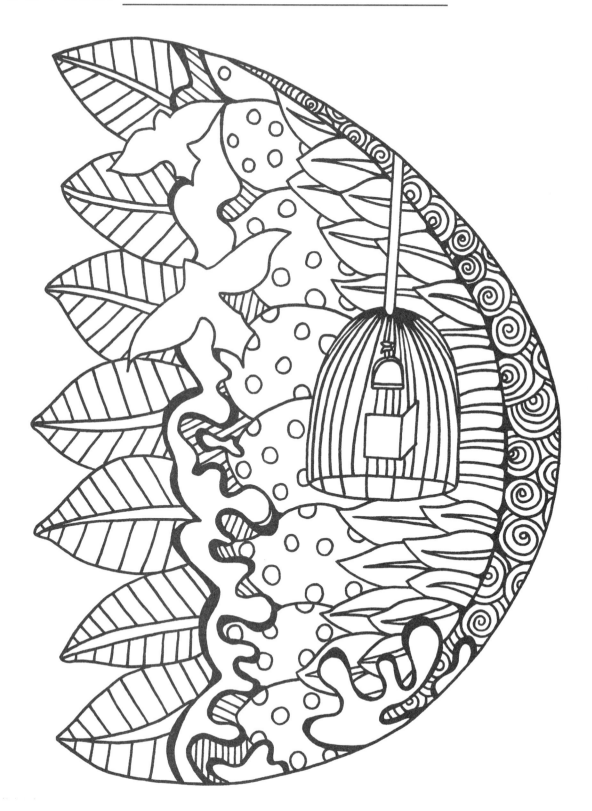

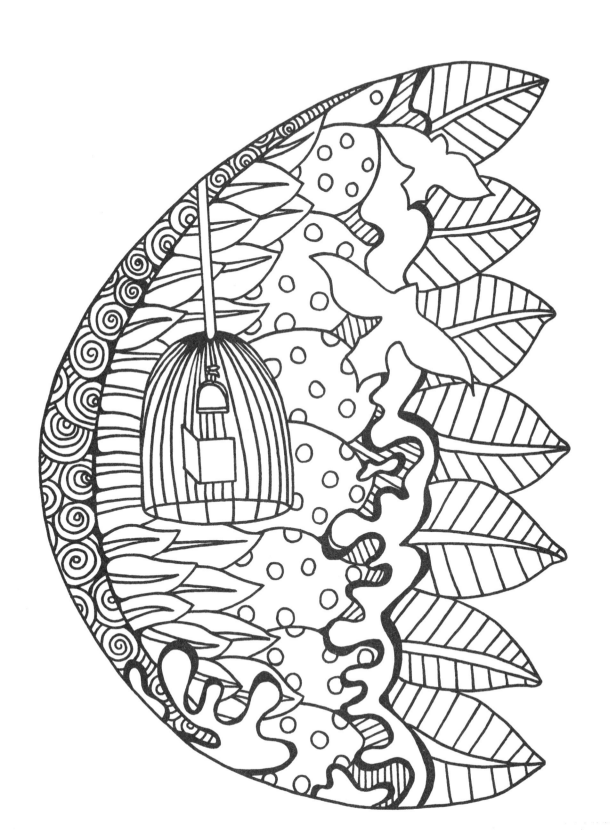

WHO DO YOU LOVE? _____

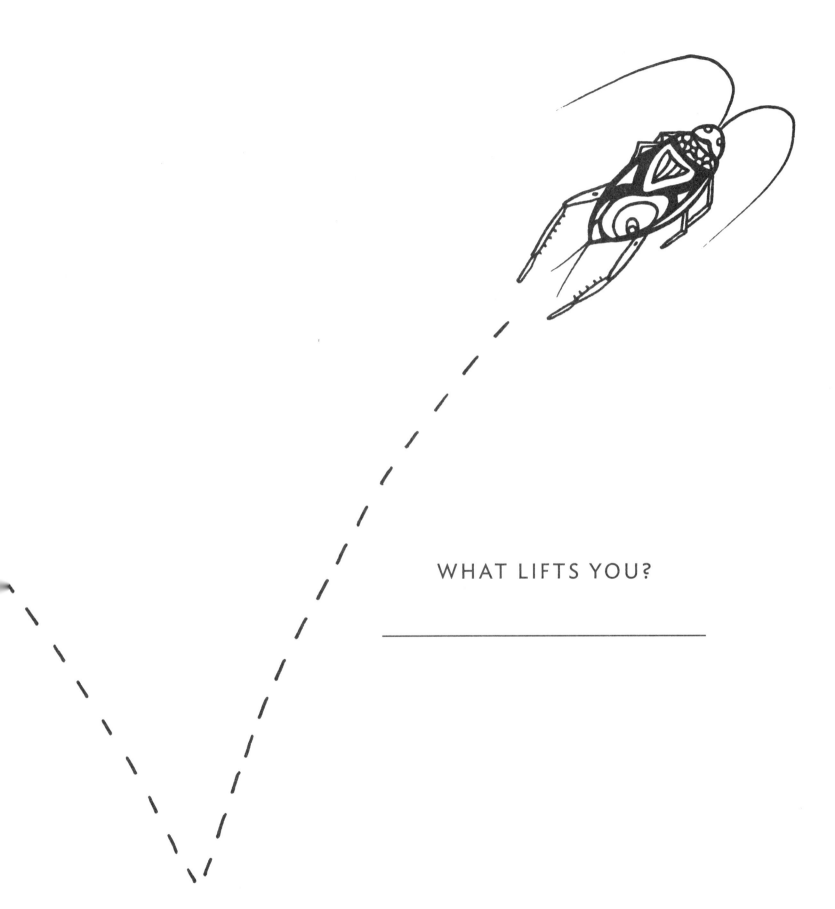

WHAT LIFTS YOU?

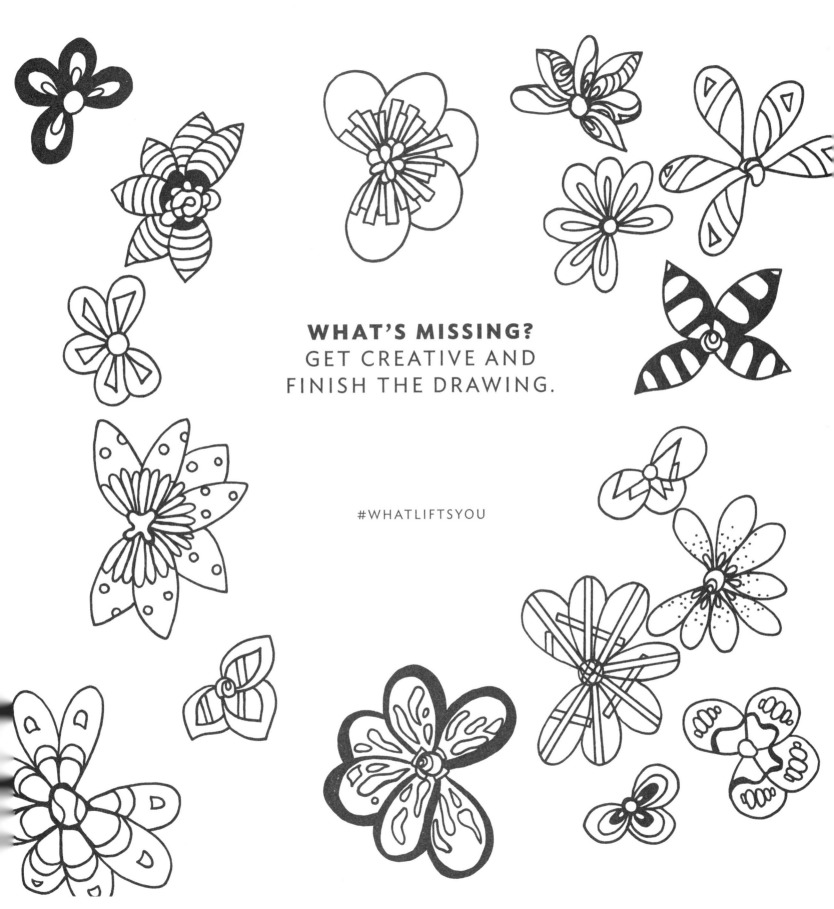

WHAT'S MISSING?
GET CREATIVE AND
FINISH THE DRAWING.

#WHATLIFTSYOU

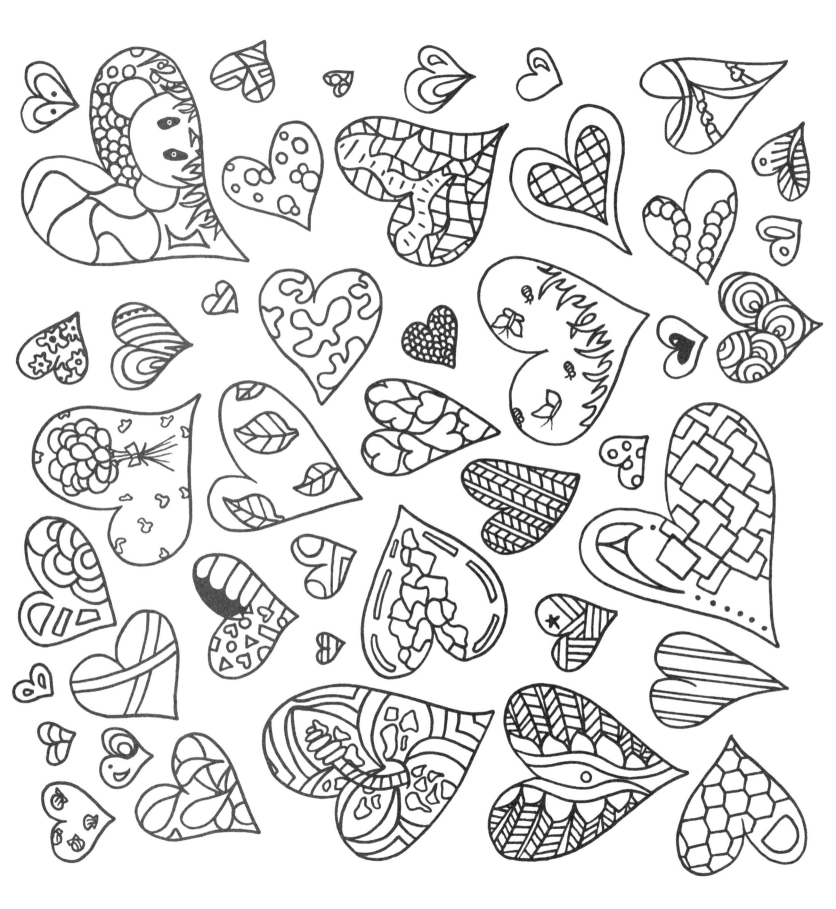

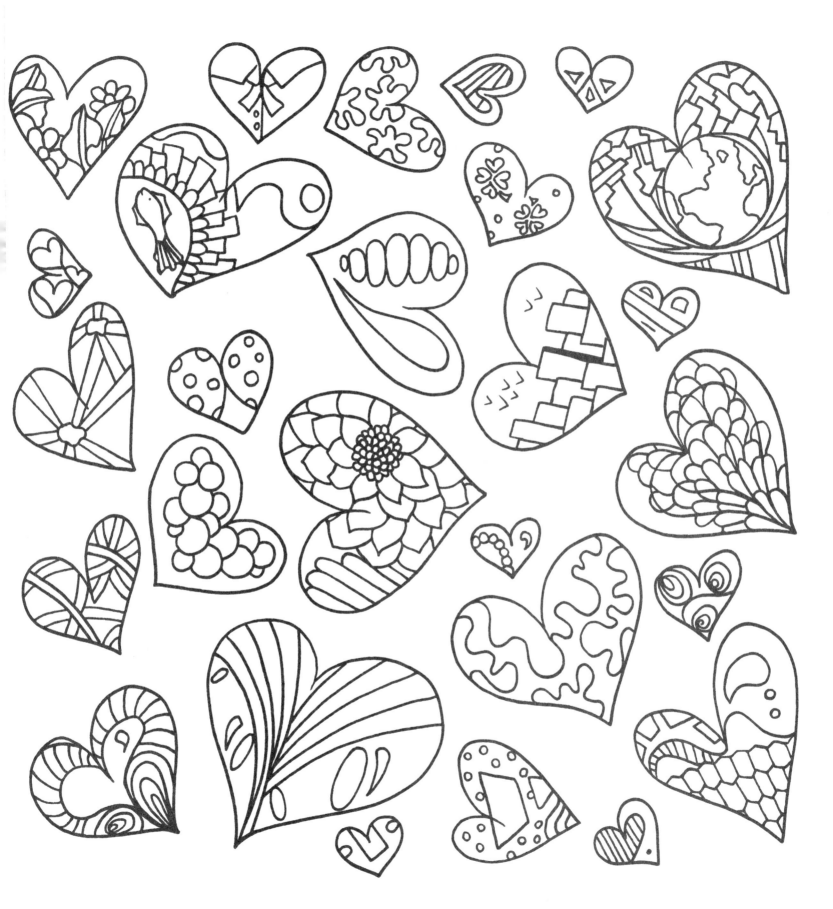

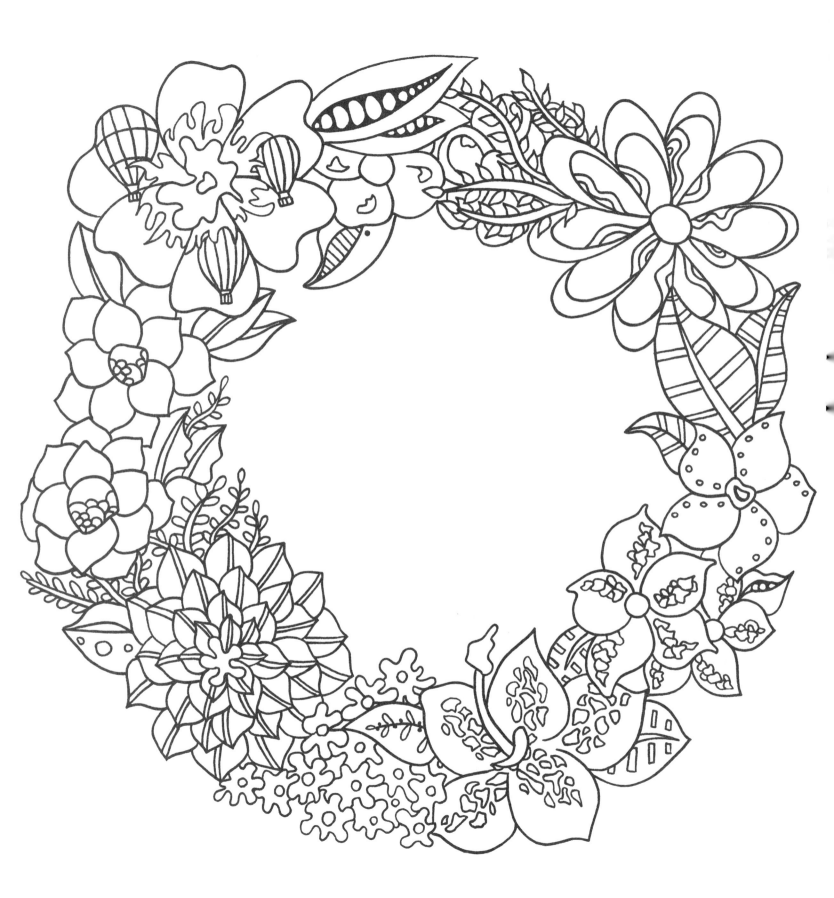

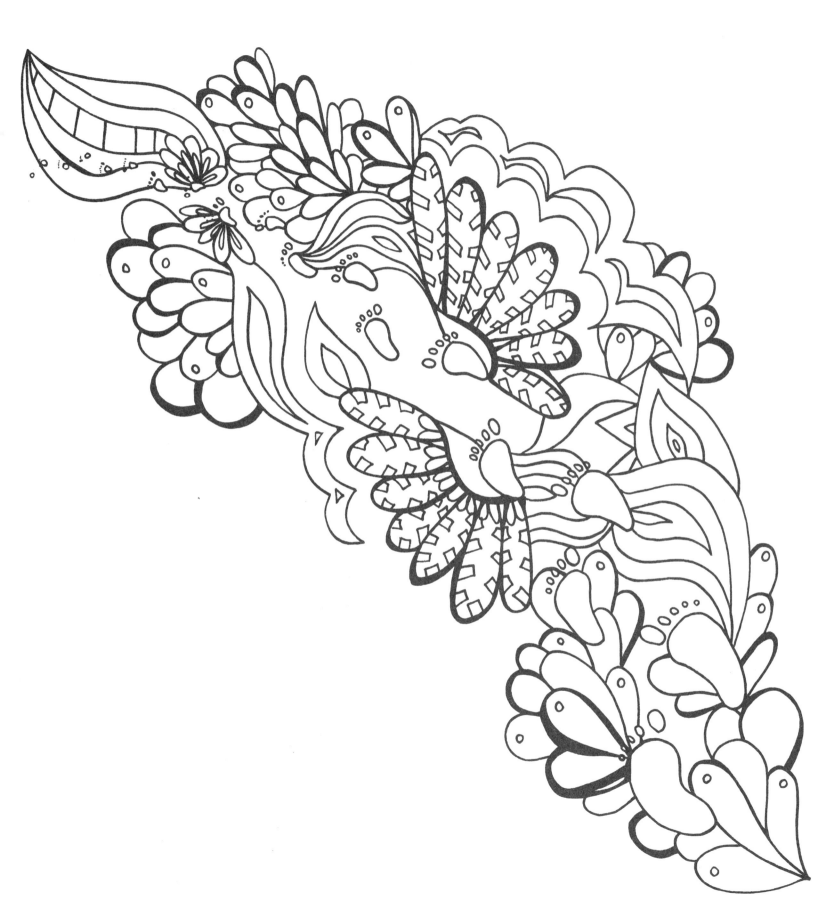

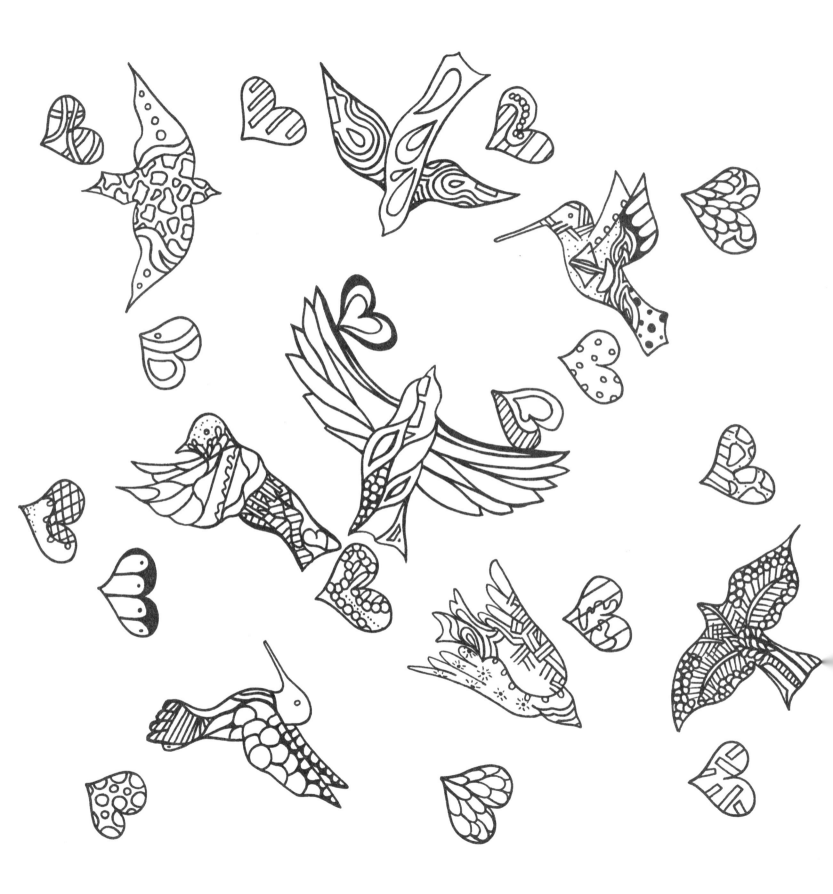

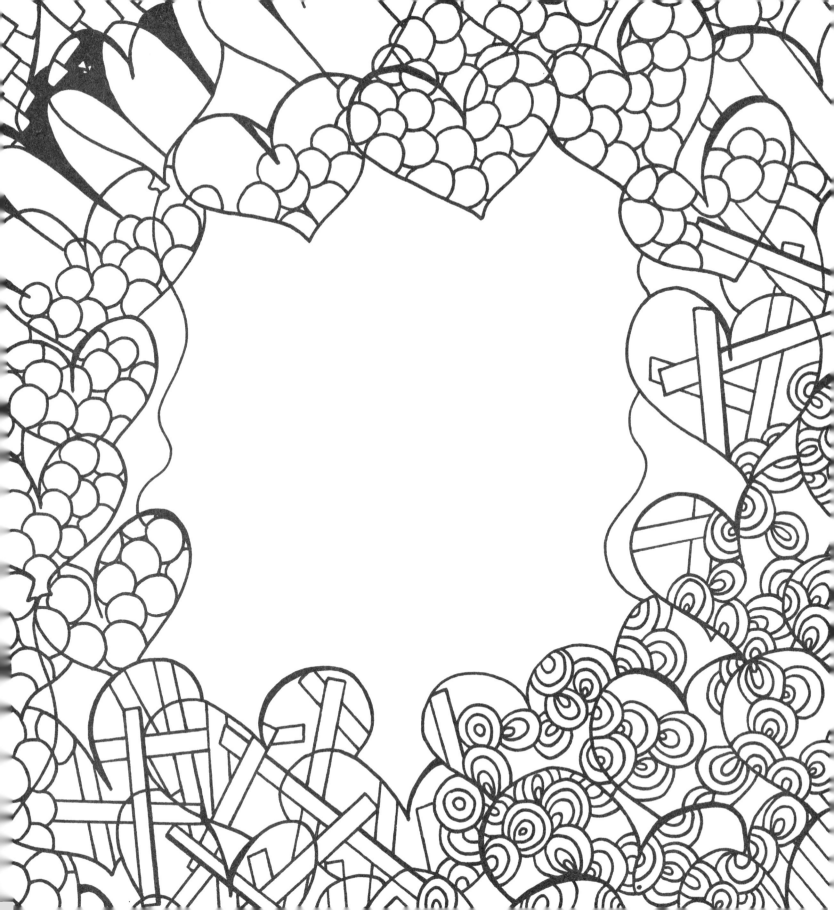

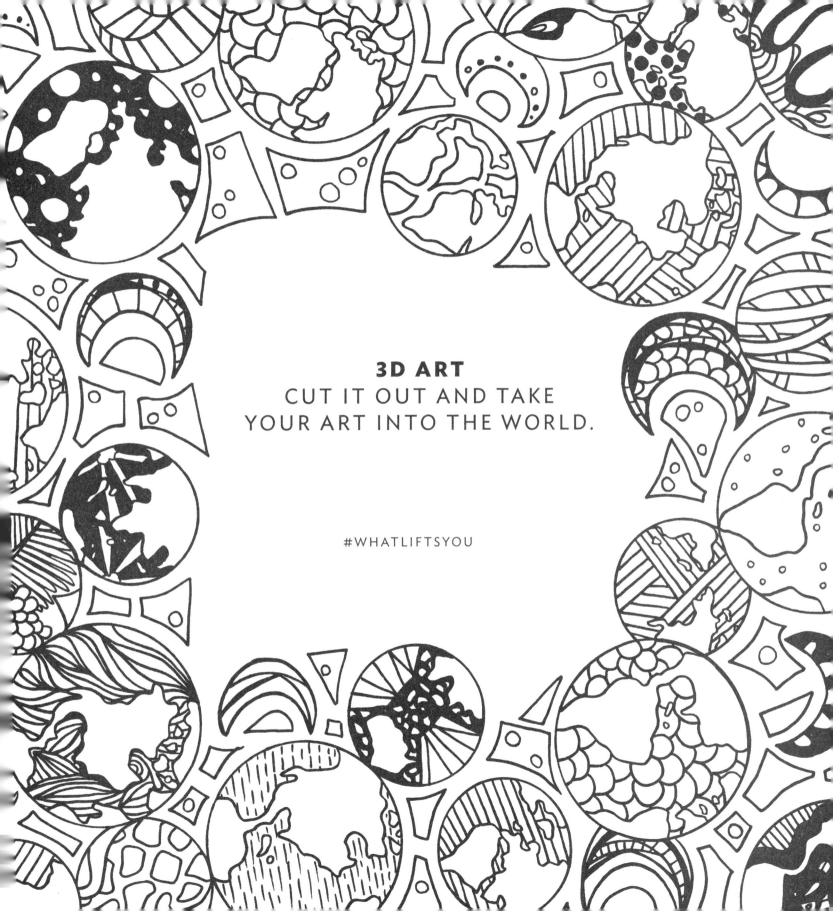

3D ART
CUT IT OUT AND TAKE
YOUR ART INTO THE WORLD.

#WHATLIFTSYOU

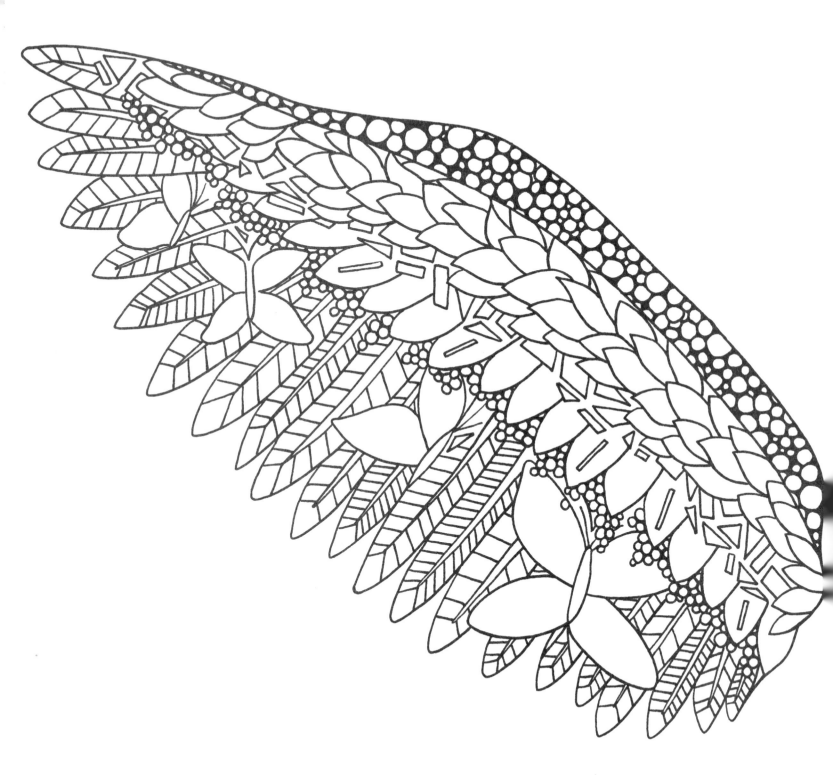

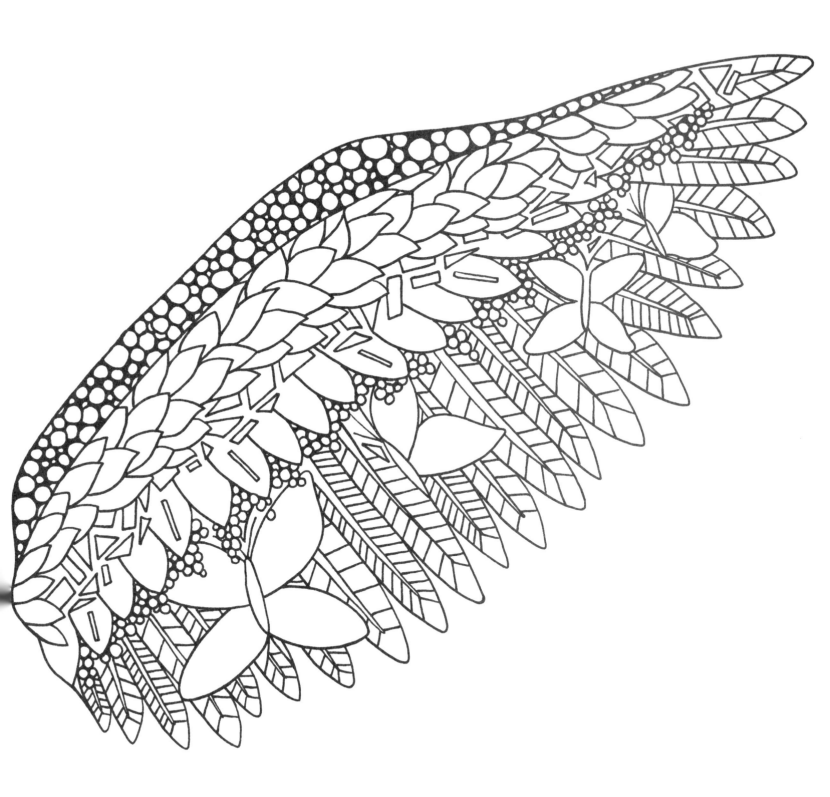

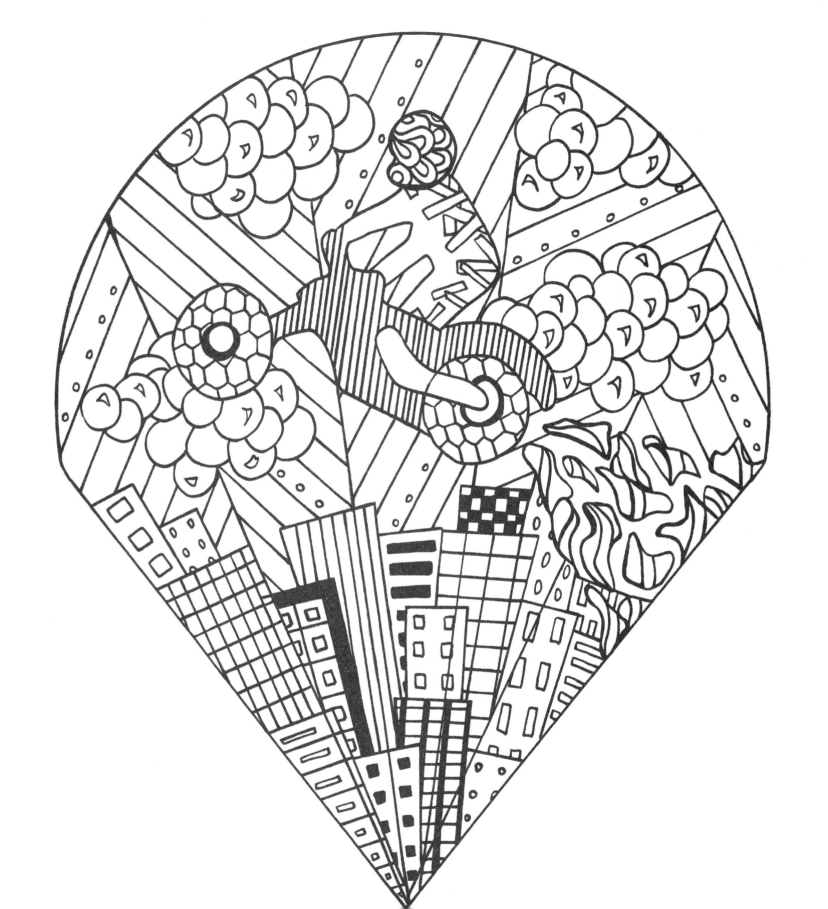

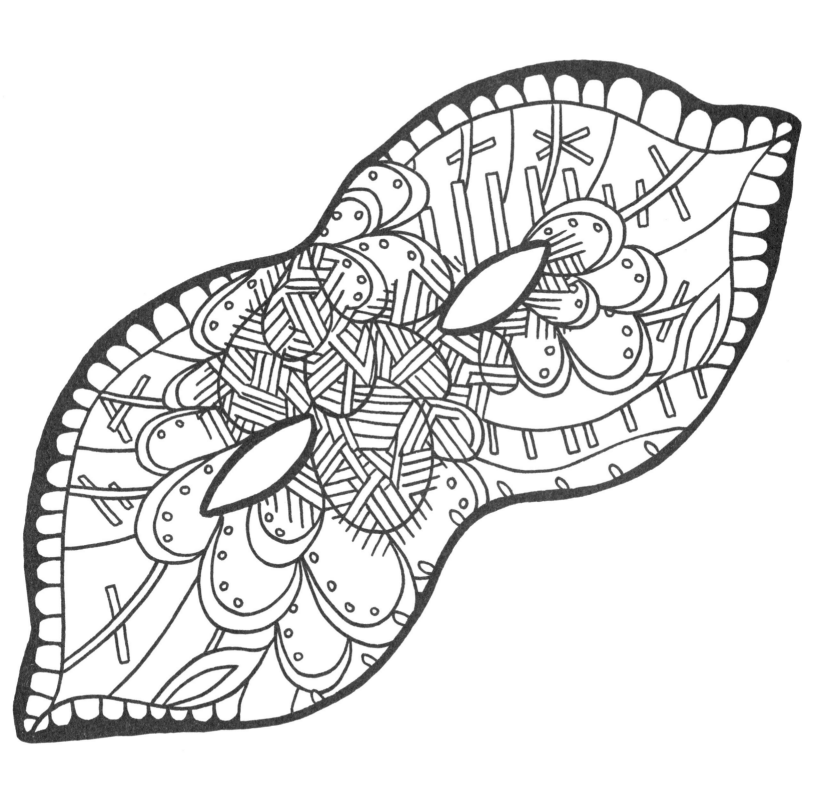

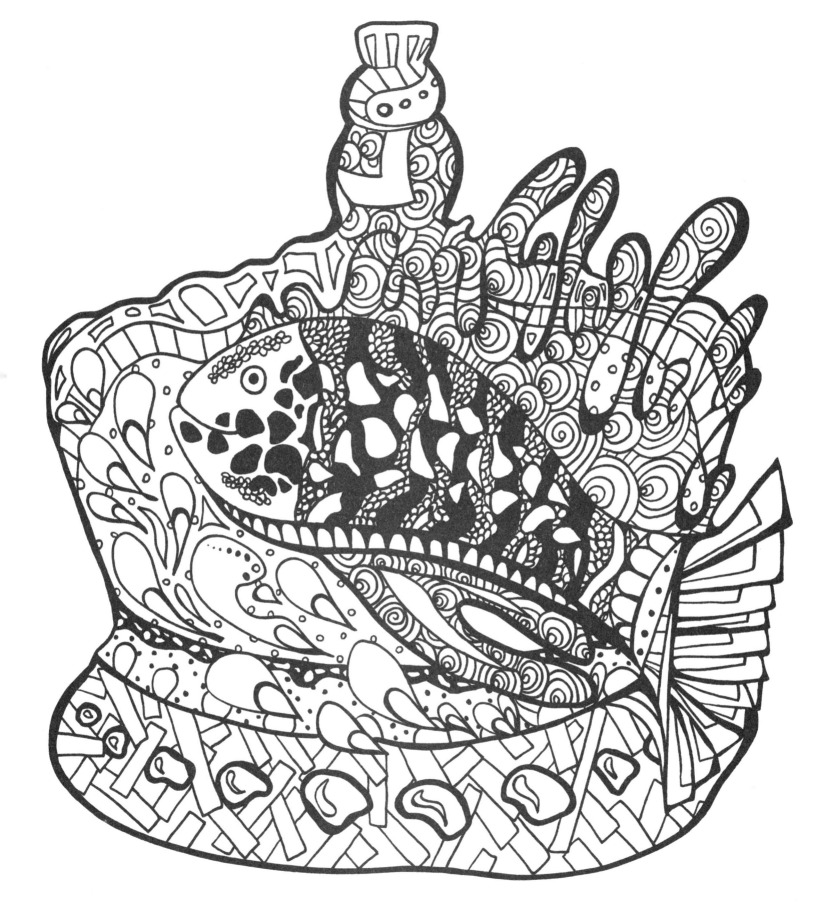

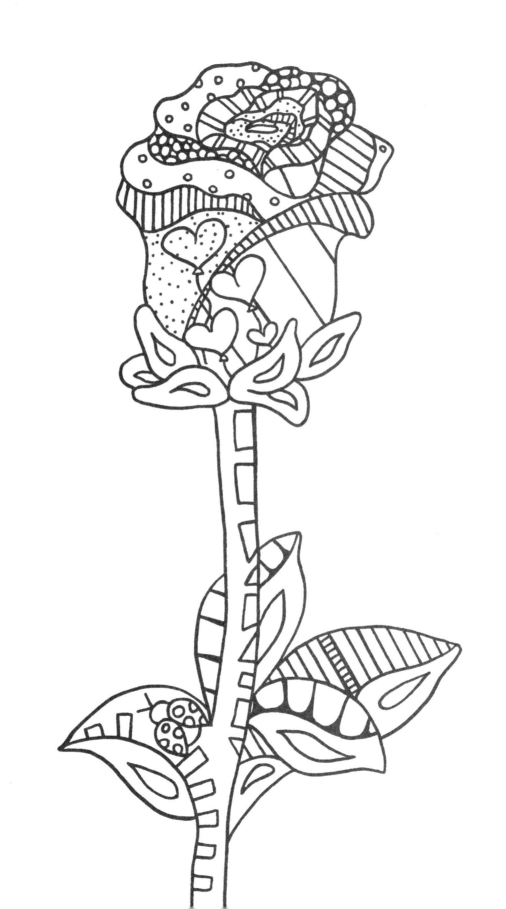

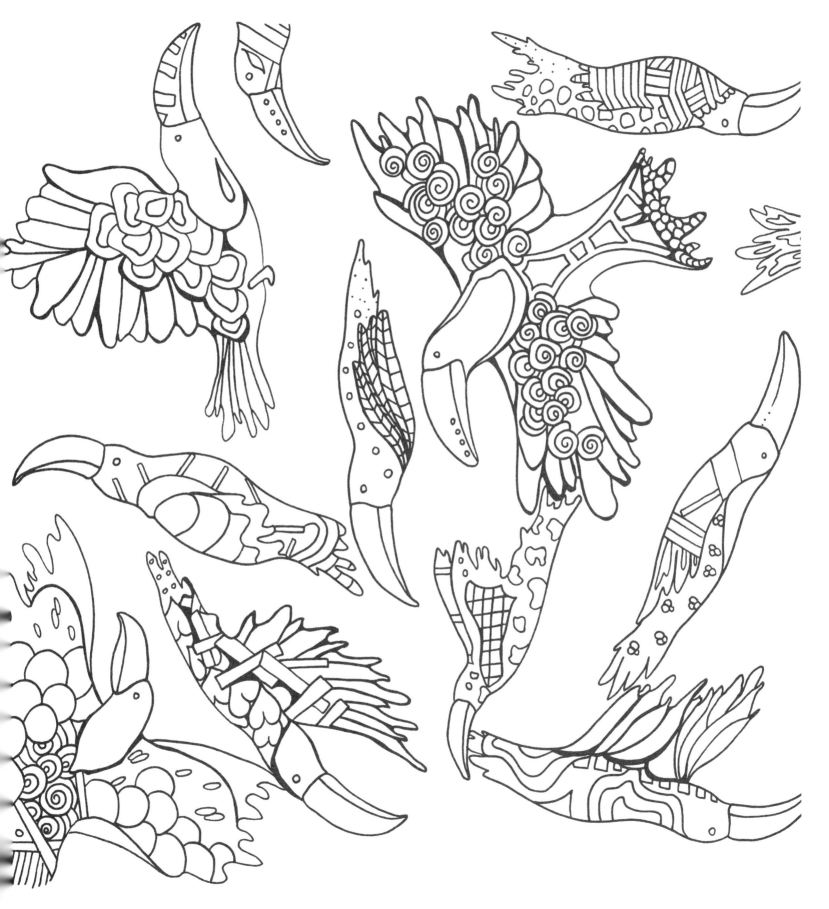

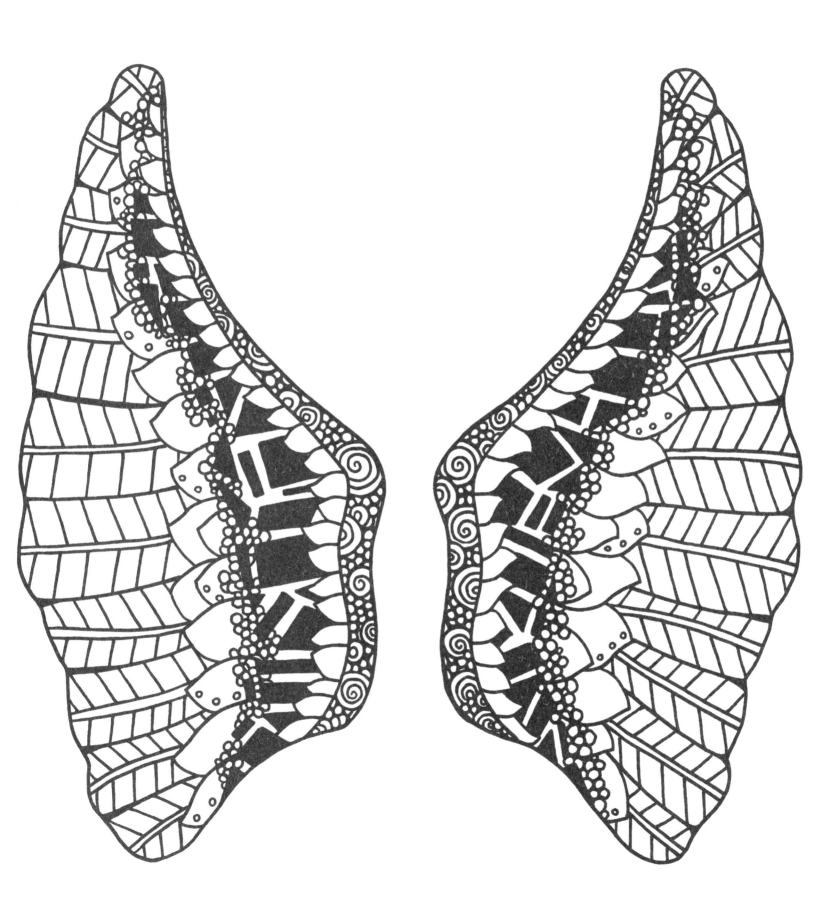

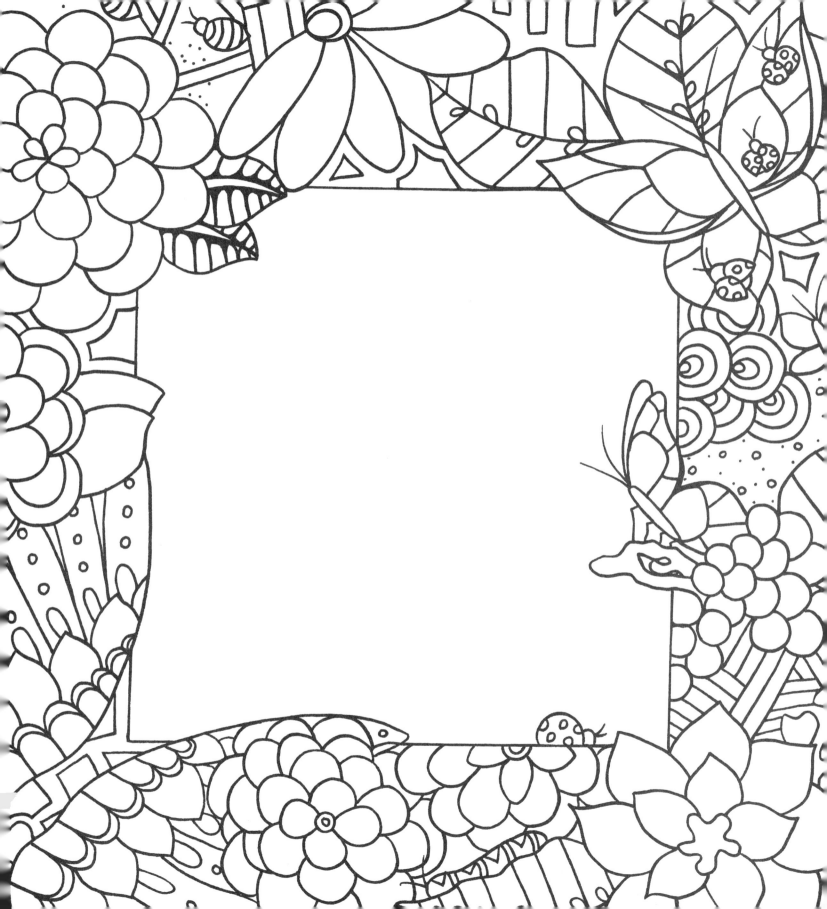

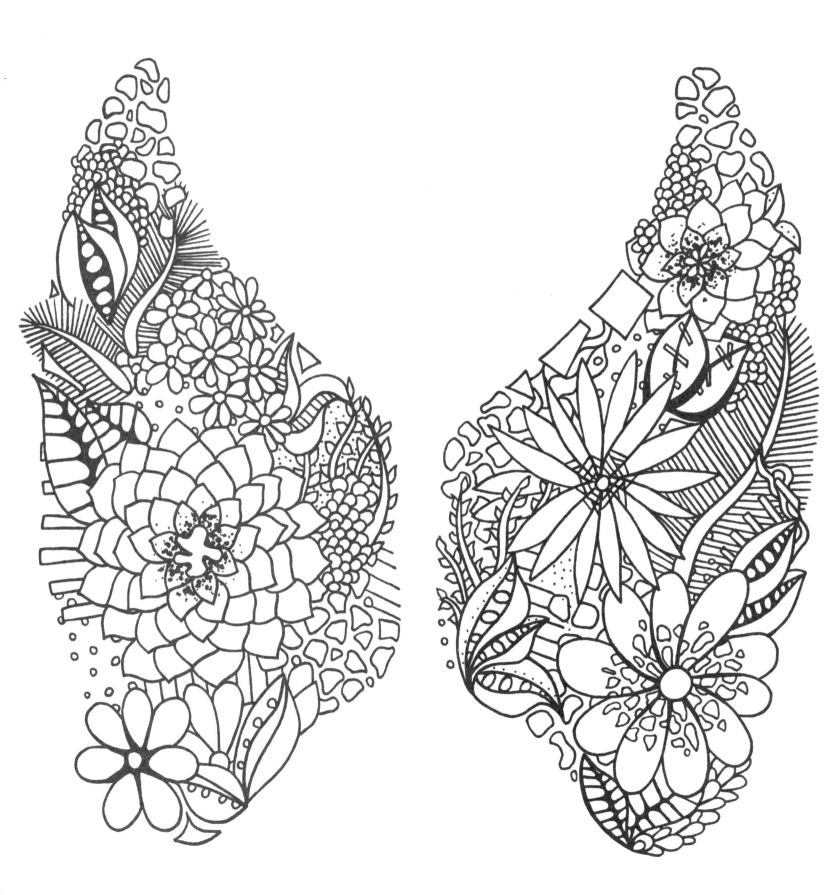